100 Clever
Digital Photography
Ideas

100 Clever Digital Photography Ideas

Getting the most from your digital camera and camera phone

Peter Cope

D&C
David and Charles

ACKNOWLEDGMENTS

A lot of people have helped me to write this book, and I'd like to thank them for their input. First, Neil Baber who suggested the idea and helped me with the early visualization. Then the team at F&W Media International including Verity Muir, Sarah Clark and Hannah Kelly, who helped turn my rough ideas into something that was a lot more fun! To Freya Dangerfield for reading and interpreting my original script, and for detecting all my poor grammar and faux pas.

I'd also like to thank Danny Chidgey at Contrado Imaging for letting us use some great images of the photo-based product his companies produce. To Nikon, Olympus, Canon, Panasonic, Apple and Nokia for the use of images featuring their kit.

Finally I'd like to thank my family for standing in as impromptu models for some of the shots in the book and for letting me use photos from our holiday albums to illustrate some of the clever ideas!

PICTURE CREDITS

CONTENTS

INTRODUCTION

There was a time, not so long ago, when photography was in serious decline. Armed with more and more sophisticated kit, amateur and enthusiast photographers were shooting away as they had always done. But the wider picture was quite different. Although cameras were becoming easier to use and more proficient at delivering great shots, people just weren't buying them as they once had. It seemed that they didn't like hassle: the hassle of carrying a camera and film; and the hassle of taking films for processing, then waiting patiently for the prints. It seems results were required immediately and, unless you were willing to wield a bulky Polaroid camera, cameras just didn't deliver.

However, technology was about to change this situation dramatically. As needs changed and demands for more immediate results became more pressing – in every walk of life – the digital camera came of age. What had been something of an expensive toy for computer enthusiasts only, now became mainstream. Taking digital photos became straightforward and viewing them, immediately, just as easy. The change within the camera market was dramatic; in a very short time cameras began to fly off store shelves again. Digital cameras had restored photography's popularity; in fact, camera use was now greater than it had been at any time in the past.

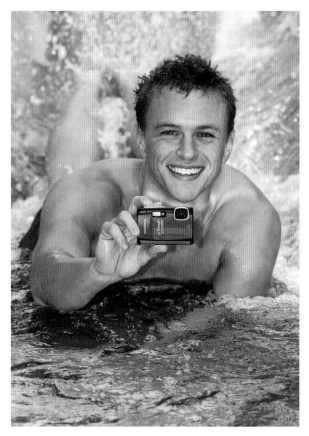

Waterproof cameras: these give you the means to take your camera almost anywhere

Today, camera ownership has never been higher; each year the record for the number of photos shot is smashed. And of course, cameras are now more than just cameras that take basic photos; they can shoot video or even 3D shots. Indeed some 'cameras' aren't actually cameras at all: mobile phones are equipped with potent cameras that shoot movies, too. This means that not only do we shoot more photos now, we also shoot subjects we may never have contemplated as subject material in the past.

Camera with flip-out viewing screen: these are great for taking photos at any angle

Camera phones: today these devices are not only adept at shooting photos, but perfect for sharing them, too

Camera phones: ideal when you want a small, pocketable all-purpose device

When cameras used film every shot cost money and, unless you carried copious amounts of expensive film, every shot you took would have to be carefully considered. Today those limits are gone and everything has become – in a photographic sense – fair game for shooting with your camera. We can use our cameras not only to record treasured memories, but also to record more mundane events that may still be pictorial, and do more besides. In this book we'll explore some of the many ways we can use cameras and camera phones today. Some ways you may have already explored; other ways will seem a little more off the wall.

Whatever camera you own, we hope you'll find some surprising and useful ways to use it better in this book.

PETER COPE

Digital cameras: allow you to enjoy or share photos at any time – and just about anywhere

USING THIS BOOK

Directly beneath the title for each idea, you'll see one or more icons; these denote the following:

The idea is suitable for a digital camera

The idea is suitable for a camera phone/smart phone

The use of a phone app is suggested

The use of computer software is suggested

An easy, medium or hard difficulty level

Although we have done our best to avoid extensive photography jargon as we explain the ideas, sometimes this has been unavoidable. Please refer to the **Clever Jargon Buster** to reference any unfamiliar terms.

IS THAT IT?

Have you got some other clever ways to use your camera that have not been featured here? It can be something sensible, or something completely crazy. Let me know and your idea might make its way into the next edition. Drop me an email at: petercope@mac.com.

CHAPTER 1:
START TO MAKE MORE OF YOUR CAMERA

Professional photographers will tell you a camera is just a tool, a means to an end that, in this case, is capturing photographs. This is a rather matter-of-fact view that perhaps says more about the relationship of a professional person with the tools of their trade than about the camera itself. For the rest of us, a camera – or a camera phone – is an amazing gadget that's capable of so much. We enjoy shopping for one or receiving one as a gift, and then having fun with it. Often, though, a bit like the professional photographer, we tend to consider the camera simply as the clever tool that records memorable moments in our life.

In this chapter we'll take a look at some simple ideas for getting that little bit more from your camera or camera phone than just a

record of those memorable moments. We'll start out by looking at how you can start to explore your camera's functions, including some ways your camera can help to improve shots for auction sites and identity photos. Cameras have some ingenious ways they can help us record information and solve problems around the home and office, so we'll have a detailed look at these here. Finally, we'll look at some ways for photographing hobbies and interests, and get you started with thinking of some more creative approaches to photography, such as photo stories.

By the end of this chapter you'll recognize that your camera's something much more than just a, well, camera!

CLEVER IDEA 1:
IDENTIFY YOUR CAMERA IN THE ID PARADE

Cameras today come in a broad range of shapes and sizes, with a feature set that ranges from basic to incredibly sophisticated. What clever things can your camera do? That's something of a loaded question and can very much depend on what sort of camera you have. Take a look at this ID parade of common cameras and identify where yours fits into it to get an idea of what is possible with your device.

CAMERA PHONES

Camera features built into a mobile or cell phone.

Ideal if...
- You want a single device for both phone calls and photos
- You tend to shoot in daylight or brightly lit conditions

Not so good if...
- You require high-quality photos
- You need some control over your photos
- You shoot lots of photos in dim light conditions

COMPACTS

Cameras that are small and pocketable.

Ideal if...
- You want a carry-everywhere camera
- Most of your photos are shot in 'normal' lighting conditions
- You want to shoot great photos on a limited budget

Not so good if...
- You need the best quality images
- You want maximum control of your photography
- You shoot photos in difficult or unusual lighting conditions

LARGE COMPACTS AND SUPER ZOOM CAMERAS

Beefed-up compacts with more control features and enhanced zoom lenses.

Ideal if...
- You want more control
- You still need a (moderately) compact camera
- You require better results than a simple compact can offer

Not so good if...
- You want a small camera to fit in a pocket or purse
- You need an accurate viewfinder view

BRIDGE / HYBRID CAMERAS

These form the missing link between compacts and professional SLR cameras.

Ideal if...
- Compact size is not so important
- You don't mind an all-in-one solution
- You're not likely to want interchangeable lenses
- You want a better spec than a compact can offer

Not so good if...
- You want the highest resolution of images
- You want to shoot subjects that need specialist lenses

MIRRORLESS DSLRS

Interchangeable lens cameras with larger sensors.

Ideal if...
- You want the control and flexibility of a digital SLR
- You want to shoot in a wide range of situations
- You need more than one lens to shoot in those situations
- You want a moderately compact solution

Not so good if...
- You need an extensive range of accessories
- You are on a limited budget

DIGITAL SLRS

Top specification cameras for enthusiasts and pros.

Ideal if...
- You want the ultimate in control
- You want to shoot in a wide range of situations
- You need more than one lens to shoot in those situations
- Size and weight are not an issue for you

Not so good if...
- You want to shoot discretely
- You want to travel light
- You are on a limited budget

LOMO AND HOLGA CAMERAS

Bizarrely poor quality cameras that deliver unpredictable results.

Ideal if...
- You put fun above reality
- You want unpredictable results
- You don't mind using film rather than digital

Not so good if...
- You require accuracy in your photos

SPECIAL CAMERAS

Designed for specialized use, although often suitable for more general applications too; the more popular types include 3D/stereo models and panoramic cameras.

Ideal if...
- You are an enthusiast of 3D or panoramic photography
- You have a need for specialized imagery
- You like images with real impact

Not so good if...
- You are working on a budget
- You need something pocketable

CLEVER IDEA 2:
SHOOT FIRST, THINK LATER

Never miss a great photo because you're spending too long thinking about it. A wise photographer once advised me never to press the shutter unless I was sure everything in the frame was perfect. Subsequently, I missed many brilliant shots and, if you follow his advice, so might you. That advice would be great for the photographer who takes serious photos that are destined for competitions, portfolios and the like. But for the rest of us it's more important to just get the photo. Imagine those wonderful shots: a child's first amazed look as he or she rides a bike for the first time; the tearful glance of a bride's father at a wedding – all are too transient for us to spend too much time labouring on setting up the shot.

AN ALTERNATIVE POINT OF VIEW

Here's another quote I recall from a press photographer: 'Always have your camera with you and ready to go. You never know what's around the next corner. It could be the Queen Mother in a bunfight with a taxi driver – and one grabbed shot will make your fortune.' That scenario is naturally unlikely, but it makes a good point about being prepared.

AUTO MODE?

You can select the auto mode on the camera's mode dial, or by using the camera's menu, depending on the module. Beware, however: on some cameras with multiple modes you'll see an 'A' mode. This is not auto mode but aperture priority, a mode that lets you control the lens aperture. Often the auto mode is shown as 'auto' or a green camera symbol, as shown here.

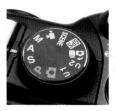

'A' for auto mode?: Confusingly, the green camera symbol here indicates auto mode; the orange 'P' is for program mode

BE PREPARED

That great shot can still escape you if you are left fumbling for your camera when the opportunity presents itself. When you see something fantastic that would make a great picture, how long does it take you to actually take a shot? It's unlikely that you'll have your camera in your hands – or around your neck – at all times. So how can you make sure that you are well prepared?

The best advice is to get your camera settings configured so that all you need do is turn on and shoot. For most cameras that means setting to the auto shoot mode as auto is perfect for grabbed shots. Many people never use auto, decrying it as the 'Jack of all trades and master of none'. It's true that it's not the perfect choice for every shot, but it's certainly the setting that will provide you with the best results on the greatest number of occasions.

AUTO OR PROGRAM MODE?

Some cameras have a program mode as well as auto and they are often assumed to be identical. In fact, many photographers use the terms 'auto' and 'program' interchangeably – however there is a subtle difference. In program mode the exposure is still handled automatically but other camera settings, that can include exposure settings, sensitivity and focusing settings, can be varied. Opt for auto if you want all these taken care of for you.

CLEVER IDEA 3:
START TO UNCOVER YOUR CAMERA'S HIDDEN TALENTS

Cameras today have an arsenal of potent features – some of them obvious, others less so. It can be a shame to miss out on the latter, as some of the less prominent features are often also the most interesting and help us make good pictures great. Many cameras now come with quick start guides that swiftly provide you with the run-down of the special features – and mean that you don't have to delve deep into the inevitably compendious manual.

Here are a few of those you might find on your camera or camera phone:

- **Face detection:** Automatically determines if you are shooting people and focuses on their faces.
- **Blink detection:** One better than face detection, this feature not only finds people in the shot but also determines whether they are blinking.
- **Smile detection:** No prizes for guessing this one. Similar to blink detection, but this time the camera will only let you shoot when it detects a smiling face in the photo.
- **GPS:** Increasingly found on camera phones, but also available on many cameras. This facility determines your position and records that data along with the photos you shoot.
- **Scene modes:** OK, not quite so hidden but scene modes quickly configure your camera to get the best action shots, portraits, and so on.
- **Auto panoramas:** Using image-editing software it's easy to produce wide, panoramic shots from individual photos. Auto panorama features make it even easier to create your panoramas in-camera as you shoot, guided all the way.

Blink detection: a perfect feature if you tend to shoot lots of group shots, as it prevents you shooting those sometimes inevitable photos when at least one person is blinking just as you press the shutter

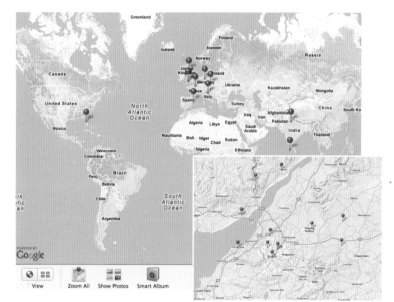

Location, location, location: cameras with GPS features can record the location where photos were shot along with other data. You can then review photos based on location, zooming in closely to the actual map, shown as here in iPhoto

CLEVER IDEA 4:
IMPROVE YOUR AUCTION SITE PHOTOS

Auction sites such as eBay are an increasingly popular way of clearing out unwanted items. Yet people do themselves no favours by posting mediocre photos for their goods, often resulting in no sale. Give your items a head start by making sure they're displayed to best effect: here are a few 'dos' and 'don'ts' that will ensure you have the best chance of actually selling your auction items.

DOS AND DON'TS OF AUCTION SITE PHOTOGRAPHY

Do:
• Avoid distracting backgrounds. Pro photographers will use paper rolls or special backboards, but you could use the back of a roll of wallpaper, or even bed sheets for larger items.

• Take multiple shots if you need to show different aspects or angles of your object. Yes, it costs more to show these shots but it does increase the chance of a sale – or can enhance the final sale price.

• Match the size of the shot to the subject. If you've got a small item, shoot up close to feature the details.

• Take shots of notable details, whether special marks or damage, that might be important to some buyers. Damage particularly can be contentious; a slight mark to some people can be a deal breaker to others.

• Remember to show everything, including photos of all the accessories or relevant packaging. Some buyers, for example collectors, will want to see the condition of the box and regard this as important as the condition of the item itself.

• Try to avoid taking direct shots with the camera flash as this can lead to harsh reflections and equally harsh shadows. Better to go without flash and use daylight, diffuse if possible. Use a tripod or an impromptu support to allow for longer exposures.

• Take photos at a high resolution and trim them down later. Although eBay allows modest resolutions, taking a photo at higher resolution allows you to send a better photo direct to prospective buyers should they request one.

Don't:
• Use stock shots of the object you're selling: people want to see the actual item for sale – and it probably breaches copyright, that will result in your listing being cancelled. Similarly, don't copy images from other listings of similar items.

• Use low-resolution images – instead go for the highest resolution you can. Cameras and camera phones can deliver great images so why compromise? Requirements vary from site to site, but aim to use an image of a minimum of 2MB in size. The better the image, the less chance your prospective purchasers will need to ask questions or ask for more details – and the greater the chance of a sale.

Auction photos: do remember to show everything you have for sale. This will avoid possible disputes later regarding the items and their quality

Show details: if you are selling something with a fault – or conversely, if it is in pristine condition – show it

CLEVER IDEA 5:
SHOOT IDENTITY PHOTOS

An ever-increasing number of documents – travel passes, driving licences, membership cards, visas and more – demand photographic evidence of identity. Why not save time and money by shooting them yourself? It's really not that difficult to shoot good ID card photos. What is important, though, is that you closely follow the guidelines published by the issuer. Most are broadly similar and some of the most common are detailed below.

(I) IDENTITY PHOTO GUIDELINES

Here are suggested guidelines for shooting good identity photos:

- If multiple photos are requested, they must all be identical

- Photos must be taken recently (within one month)

- Photos must be shot in colour

- Photos must be of a specific size – normally 35 x 45mm (1.38 x 1.78in) – but not trimmed to this size

- Photos must feature head and shoulders, and must take up most of the photo frame

- Photos must have no shadows

- Photos must be taken against a neutral background

- Photos are best shot without glasses to avoid reflections, with eyes looking directly into the camera

- Photos must have a neutral expression. Don't smile!

- Photos must be sharp

TIP

It's very tempting to try and improve on the guidelines but don't; you risk rejection and having to start your application all over again. At best this is time consuming – but it could be costly.

PASSPORT PHOTOS

There's no reason why you shouldn't shoot your own passport photos if – and it's an important 'if' – your results are of sufficient quality. Passport offices often demand 'professionally shot' photographs or they reserve the right to refuse an application. Ensure, if you do submit your own photos, they are of comparable quality – as well as meeting all other requirements.

SHOOTING IDENTITY PHOTOS

Here's how to shoot the very best ID photos:
- Choose a background carefully: a neutral, white/off-white/light grey wall is best. If you can, stand your camera on a tripod or support to help you position your subject accurately.
- Stand your subject a little way forward of the wall to avoid shadows. For best results your camera should be positioned around 2m (6.5ft) away from the subject and adjusted to capture a good head-and-shoulders shot.
- Avoid using the on-camera flash, as it will create harsh shadows around the subject. Instead, use natural light if it is bright enough, or an external flashgun if you have one, to bounce light off the ceiling.
- Ensure your subject is in sharp focus, with a focus on the eyes.

Shooting ID photos: a face-on portrait, without a hint of smile, is what's needed

CLEVER IDEA 6:
CREATE A VISUAL INVENTORY

It is with a certain degree of inevitability that inventory disputes in regard to contents and damage are a regular occurrence when renting properties and holiday homes. If we've not experienced a dispute ourselves, we can probably point to a friend or relative that has.

The problem is, although most rooms, apartments and homes have inventory lists, we often sign up to a rental or tenancy agreement without any review. And that can be asking for trouble, as it's easy for either party to overlook something and for you, as the renter, to be held liable.

HOW DO YOU CREATE A VISUAL INVENTORY?

First, you don't need any photographic skills as such: you're not aiming to take photos that will become competition winners, you're taking record photos. Let's say you've hired a holiday home – the same rules (although 'rules' is perhaps too strong a word) apply no matter what the property.

Begin by taking some general shots of the rooms as you inherited them, then carry out a quick survey for any damage. Look behind doors and in cupboards for dents and marks in plasterboard, stains on carpets, and cuts, marks and blemishes on soft furnishings. You'd be surprised what some unscrupulous landlords would try and bill you for, or deduct from your deposit. Take shots, too, of the contents of cupboards, showing what's there and what's not. And don't forget outdoors, if you are liable for the maintenance of grounds or gardens.

Once you've shot your collection of images, keep it safe. If your agreement says so, you may need to provide evidence of damage immediately, rather than keep it for comparison when you leave. Whatever the rules, though, you'll have the peace of mind that you've done all you can to avoid disputes.

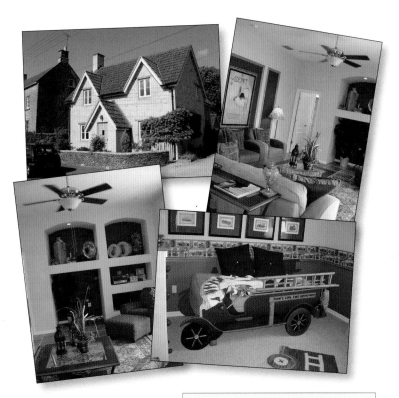

Holiday home inventory: avoid disputes with a few shots of your let on arrival

DON'T BE AFRAID!

Some landlords will drag you around their property pointing out how everything is in pristine condition. Don't be afraid to use your camera on any tour to reinforce the survey. It will also demonstrate to the landlord (the vast majority of whom are honest) that you're serious about the inventory.

WORKS BOTH WAYS

If you own a holiday home or rental property don't forget that you can create a visual inventory yourself – and get your tenants to agree with it. You could even give them a copy.

RECORD THE DATE

Even with the most prolific photographic evidence you can still have disputes. How is the owner of the property to know that you didn't take photos of, say, damage on your day of departure? It's a good idea to lodge your photos somewhere the date they were taken cannot be disputed. Think about a photo site (like Flickr) where the date of posting is recorded. Don't rely on the camera's date stamp as solid evidence – it's too easy to change.

CLEVER IDEA 7:
RECORD A CAR SMASH

We don't like to think about it, but we could all be involved in – or witness – a car crash. Emotions run high afterwards, even if the incident is relatively minor; we tend not to think straight and can rarely recount facts correctly. And this is the very time when police, legal professionals and others expect us to be explicit in every detail.

Using a camera to record the incident can help you in all these respects and can also avoid cases of fraud. Fraud? Yes, drivers have been swapped, different drivers have turned up in court, and even different damages have been claimed. Shoot the damage to both cars, the people involved – again in both cars – and the location. Add in a general view of the crash area, showing weather conditions.

TIP

Shoot as many photos as you can of the crash scene; the more the better.

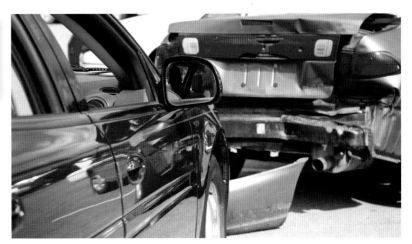

Ouch!: Use your camera to record details of the vehicles and occupants when the worst happens

KEEP A CAMERA IN THE GLOVE BOX

Got a spare camera or an old one? Keep it charged and in your glove box so you're always ready to record the unfortunate, even if it's something you're not directly involved in. Definitely use an old camera, though – we'd never recommend leaving cameras in cars for security and other environmental reasons.

CLEVER IDEA 8:
CREATE A HOME INVENTORY

We may not like talking or even thinking about it, but each year many people suffer losses to their home and their valued possessions. It could be through theft, fire, or simple carelessness. Whatever the reason, that sense of loss can be compounded when subsequently dealing – or arguing – with insurance companies and loss adjusters. You can minimize – or even avoid – disputes with insurers if you have a complete and accurate record of your possessions. Here are two options for creating your inventory:

OPTION 1: A SIMPLE PHOTOGRAPHIC CATALOGUE OF YOUR VALUABLES

Spend a couple of hours taking some photos of the possessions in your home and – if relevant – elsewhere. Shoot them in situ, so you can show where they were prior to, for example, a theft. Pay particular attention to those items for which you don't have (or won't have) any other documentation, such as the receipts, that insurers often ask for.

Record details such as special marks or damage that might alter any subsequent valuation; also record serial number panels. Your photos need not be of top studio quality, but sufficient to accurately record the item and make it readily identifiable. Keep a copy of the photos safely – on disc perhaps – along with other important documentation.

OPTION 2: INVEST IN HOME INVENTORY SOFTWARE

Software applications help you adopt a more rigorous approach to catalogues and inventories, letting you combine photos and relevant paperwork so they are instantly accessible. This makes the task of setting up a catalogue as easy as possible – Liberty Street, My Stuff Deluxe and Home Inventory are just some of the names to look out for when auditioning home inventory software.

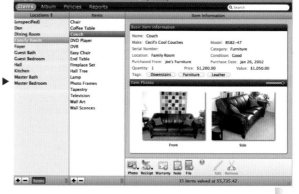

Update on the go: some applications let you update your inventory via your camera phone ▼

Home inventory ▶ software: the software option makes it easy to record shots and supporting information, so it is all easily available in just one place

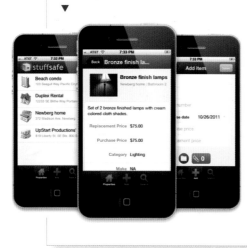

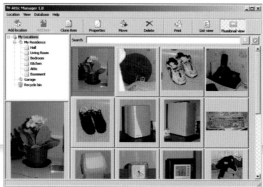

◀ Simple inventories: this simple Explorer-style application makes it easy to organize photos into rooms or categories

TIPS FOR PHOTOS OF POSSESSIONS

Here are some useful tips for getting the best results, whether you use applied software or a do-it-yourself approach:

• **Shoot clearly:** Take multiple shots of the valuable items, including any specific details.

• **Show condition:** Take shots that demonstrate the condition of items; if you've something that's worth more in pristine condition, make sure you record that condition.

• **Shoot room views:** Take shots of a whole room to show your valuables (and those not so valuable items that still need be taken into account) in situ.

• **Jewellery and precious items:** Record these individually, again showing any defining marks. It can help to introduce something – a tape measure, ruler, or even a coin – to provide a sense of scale.

KEEP IT SAFE

A home inventory – whether a collection of photos or a full-blown catalogue – is an important record. Keep a copy of any inventory and photos offsite: you don't want to risk your records being stolen or otherwise destroyed. This could be a physical copy stored with friends or family, or an online copy you can access from anywhere. Some software applications provide online storage for this very reason.

PHOTOGRAPH NEWLY BUILT HOMES

People seem to enjoy visiting newly built homes and many of these visitors, you may not be surprised to hear, are not in the market for a new house. Lots of people just like looking for inspiration for their own home. With the latest space-saving ideas, cutting edge appliances, the coolest fashions for walls and furnishings, you can be spoilt for ideas.

Of course, some people do go hunting for their dream house. Yet after a couple of days viewing show home after show home, they return to their own house, unable to recall what they saw where. So whatever your reason for visiting, take your camera. Shoot an exterior shot followed by the interior details. Problem solved!

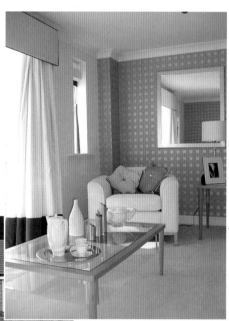

New homes: correlating interior details with homes can be problematic if you visit too many. Let your camera resolve any puzzles instead

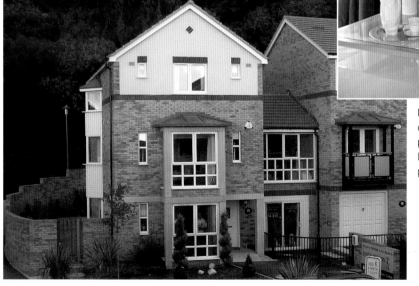

CLEVER IDEA 9:
COPY WITH YOUR CAMERA

Didn't someone say some time back that increased computer use would lead to paperless offices and paperless homes? Whatever happened? We seem to be printing more than ever! In order to redress the balance, let your camera help a little. Utility bills, phone bills, mortgage payments, bank statements, credit card statements – I'm probably just scratching the surface of all the documents you have to keep tabs on every month. How often do you find that when you have to query something, you just can't lay your hands on the requisite form?

Why not double your chances of locating your key documents by keeping a digital copy. Set your camera to macro mode and take a shot of the paperwork; no need to be precise, you just need to capture all the information. Once you've started your digital document collection, create a folder on your computer – or in your digital photo album software – to keep the documents. When you download the photos from your camera, simply drag any document images collected to the appropriate folder.

EASY RETRIEVAL

Give your documents sensible names and keep to a simple naming convention – it'll make finding and tracking down those documents later much easier. Don't forget that you can mix documents in these folders – for example, you can keep images of your printed documents alongside your Excel spread sheet of expenses and expenditure.

Digital documents: all your important documents can now be kept safe together

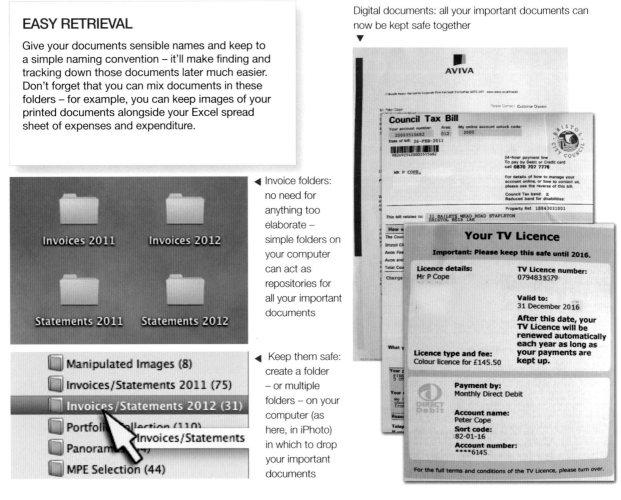

◀ Invoice folders: no need for anything too elaborate – simple folders on your computer can act as repositories for all your important documents

◀ Keep them safe: create a folder – or multiple folders – on your computer (as here, in iPhoto) in which to drop your important documents

EMAILING FORMS

Chances are, when you query something – a payment, a date – you'll be asked to provide evidence in the form of a copy of an invoice or receipt. Of course, another advantage of having digital copies of all your key documents is that you can just email a copy. No physical photocopying and then using traditional mail to send it off.

MEETING AND LECTURE RECORDS

Rather than taking copious notes from a whiteboard during a meeting or lecture, why not just take a photo instead? Then there's no chance – or no excuse – for recording things incorrectly.

Whiteboards: taking accurate records is never easy or fun, so just capture a screen shot with your camera instead

(I) SERIOUS COPYING

Cameras are also used as photocopiers in the commercial world: whole books are now being scanned and made available as digital copies. For example, self-styled digital librarian and founder of the Internet Archive, Brewster Kahle, has set about producing digital copies of as many books as practical – and copyright – restrictions permit. He uses a system that photographs the original book in its original binding, thus preserving the context of the original source.

The mechanism used at the Internet Archive is, in principle at least, the same as you or I might use to record our personal documents. The only differences are that the cameras are specially configured to best reproduce the pages of books without distortion, and that the book and camera are held in a special frame to ensure pin sharp reproduction.

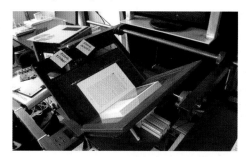

Serious copying: one of the industrial-scale copying rigs at the Internet Archive (courtesy Dvortygirl)

CLEVER IDEA 10:
CATALOGUE YOUR FRIENDS

Documents respond well to being catalogued, but what about extending this idea to your friends and family too? Start grabbing photos of them to build them into your applications.

Just about all smartphones will let you attach an image to a contact. You can use these same images on computer apps – address books, for example – and even to identify emails using some email servers. It's much quicker, and sometimes safer, to assimilate visual information than the corresponding words.

Gmail allows you to add a photo to an email address like this:
• Go to Contacts and search for, and click on, the contact for whom you wish to add an image
• Click Add a Picture
• Click Select Image and choose an appropriate image
• Modify the image if necessary
• Click Apply Changes

CLEVER IDEA 11:
ESTABLISH IF YOUR REMOTE CONTROL IS WORKING

From simple devices such as those that control the brightness of a lamp, through to powerhouse devices that operate home cinema systems and much more besides, remote controls have become an essential, if unsung, part of our lives. We take them for granted and expect them to perform – or enable the device they control to perform – on demand. So when pressing the button or touching the screen on the remote for your TV, garage door or light produces no result, how do you know if it's a failure in the remote or something more serious within the actual device?

A solution is at hand. The signals broadcast by a remote control tend to be infrared and invisible to our eyes; fortunately, digital cameras can generally see these wavelengths. Once you've turned your camera on, look at its emitter – usually along the front edge of the device, behind a darkened plastic window – in the LCD screen. If the remote is operating normally, when you press buttons on it you'll see a light – whitish usually – from the remote's LED window (the infrared emitter, as shown in the photo) confirming that the remote is transmitting happily. If there is no light, the remote is probably faulty. Sadly, cameras can't diagnose problems yet, but at least they can help avoid unnecessary service calls.

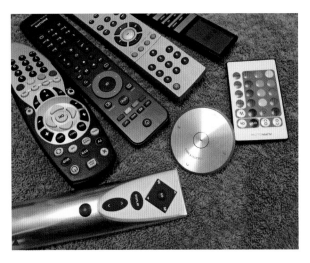

Remote controls: they were designed to make our lives easier and indeed they do, until one of them stops working…

(I) RADIO FREQUENCY REMOTES

This cunning trick won't, perhaps obviously, be able to diagnose problems with remote controls that work on radio frequency, rather than by light. So how do you know if your remote is radio frequency? Usually they function through walls or without easy line of sight of the device. And they are much less common than conventional infrared devices.

Active infrared LED: seen on a camera's LCD panel, a working LED glows blue or white
▼

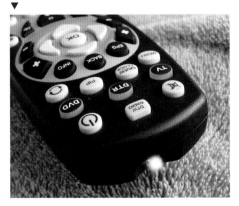

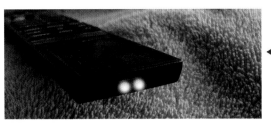

◄ Twin sensors: some remotes feature twin transmitting LEDs, as shown here

CLEVER IDEA 12:
SEE AROUND CORNERS

That home integration that brings many of our electronic gadgets together means they have to be connected. Aerial leads, SCARTs, HDMIs, network cables and more, all seem to conspire to be placed in the most inaccessible of locations. So, do you lift that heavy TV from its wall mounting just to attach your newly acquired Blu-ray player, remembering it took two people to get it there in the first place, to search for the appropriate socket?

Instead, why not use your camera for looking around corners or the back of your appliances? Simply switch your camera to macro mode, slot it behind your appliance and take a shot. If you've a camera with a flip out-and-down screen you can even work live. Of course, it still doesn't make it easier to plug those pesky cables in, but it does make locating the sockets a great deal easier.

Around the back: fitting – or even matching – cables in areas with poor accessibility becomes easier if you can get a shot of your target

OVER AND UNDER...

Of course, there are more covert reasons for wanting to look around corners, or over walls, or under fences. A camera makes it easier to obtain a view where it might be precarious or impossible to go yourself.

CLEVER IDEA 13:
GET A BIRD'S EYE VIEW

Here's another spin on the inaccessibility angle. How about getting some aerial shots by sending your camera aloft on helium balloons? It sounds like a recipe for disaster – your treasured camera rendered into all its constituent components as it plunges earthwards from a great height – but bear with me here.

For this adventure – which is great for getting aerial shots of your home or garden, or even better for getting shots of your outdoor party from the most unusual of angles – you need a compact camera and a remote control. The compact camera is used because it's light, and you need a remote control to trigger the camera at the appropriate moment. Many cameras accept remote controls to provide

Aerial shots: even simple subjects take on a bizarre form when shot from just a modest height, with your camera raised by helium balloons

remote shutter release. Of course you'll also need some helium balloons, enough to lift the weight of the camera and that of the guy line that will secure everything to the ground.

Results, it has to be said, can be a bit hit and miss. Even when securely tied to the ground, the vagaries of the wind at even modest altitudes, a little more than roof height, can send the camera spinning – but shoot away regardless. You'll get blurred shots and you'll get sky shots – but the successful shots will be impressive. And, of course, friends will ask 'how ever did you shoot that?' Next step: flying cameras on model aircraft!

CLEVER IDEA 14:
SPY ON WILDLIFE AND INTRUDERS

You've probably seen those wildlife shows where families report odd night time occurrences: strange noises, bird food disappearing and plants being eaten. Subsequently a TV show hit squad descends and puts in place cameras and sensors to detect the intruders. As the night visitors return, they set off the sensors which, in turn, trigger the cameras.

Next morning you get to see the criminals; foxes, badgers and more obscure, shy creatures have all been shown frequenting suburbia. So if you've a similar problem, or are just a bit curious about what happens in your garden when you're not there, how about setting your own photo trap?

TURN YOUR PHONE INTO A SURVEILLANCE CAMERA

You don't need expensive kit for this, just a camera phone and a surveillance app. To mimic the expensive kit used by TV shows to record interlopers you'll need an app that detects movement and triggers the camera every time motion is detected. There are a surprising number of these available and more are added to the list all the time. Run an online search for surveillance and motion detector apps to discover what's out there.

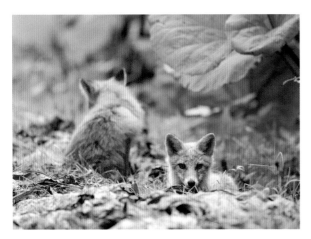

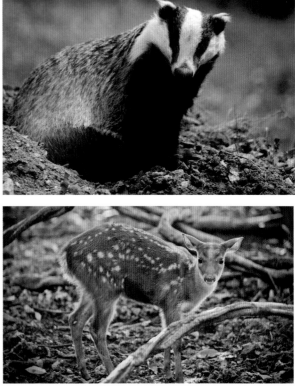

 ## HOW THEY WORK

These apps essentially work in the same way as TV kit: by keeping the camera live at all times and monitoring changes in the image being viewed. When a significant change is detected in the scene, the camera takes a photo. As such, it does tend to use a fair amount of power, so you'll either need to determine how long the camera can operate before running down, or use a power adaptor to keep the device powered throughout the period in question.

Wildlife: you never know who or what you might find wandering through your garden; use a surveillance app on your camera phone to find out

GO BATS WITH YOUR IPHONE

iBats is an iPhone app that lets you listen in to bats' ultrasonic transmissions, record them and track (using the iPhone's GPS system) their location. You do need an ultrasonic microphone, but once tooled up you can not only tune into these fascinating creatures but also provide valuable data to a worldwide network of bat watchers. Or should that be listeners?

Bat hunting: iBats helps identify and record (audibly and by location) bat populations

AVOIDING FALSE TRIGGERS

Surveillance applications work by detecting motion in the camera's field of view; when it detects that motion, it takes a shot. Unfortunately, if there are things in shot that move naturally, you may find you've collected a large collection of photos of nothing more exciting than a swaying branch or swinging gate. Although some apps are more adept at discriminating between environmental motion and that of wildlife and people, a little trial and error may be required when it comes to positioning.

YOUR CAMERA PHONE AS SECURITY CAMERA

Take your surveillance or motion detection apps indoors and you've got a great security system. You probably won't be surprised to hear that surveillance apps weren't designed with wildlife adventures in mind. Rather they were intended for home security duties. Use them to monitor your home when away or, for a bit more fun, to discover what your pets get up to when you're not there!

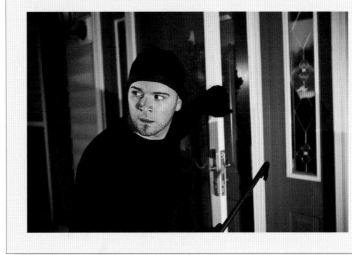

Security: camera phones are a great way to detect intruders

CLEVER IDEA 15:
COMPILE AN ASSEMBLY MANUAL

How often have you dismantled something to find, on reassembly, that you have several – apparently crucial – components left over? We've all done it, whether it's reassembling something as simple as a piece of flat-pack furniture or as complex as an automotive engine or a computer. You've attempted a repair or replacement of a deeply-nested component only to find that, when you diligently put it all back together, there's a rather serious-looking bolt, two washers and a strange-shaped piece of metal left over.

What you need is a set of photos that record the disassembly. Reviewing them in reverse order will then make sure that you include all potentially errant parts in the rebuild. In fact, at least one publisher has built its business on photo-led disassembly and rebuilding instructions; perfect if you are dismantling or refurbishing a Ford Zetec engine, or resurrecting a classic car. For more eclectic projects you're unlikely to find a ready-made instruction manual; so it's over to you.

Piece by piece: taking shots at each stage in disassembly makes perfect reassembly much simpler

HOW TO CREATE YOUR MANUAL

What's the best way to create your manual? You'll probably find it easier to mount your camera somewhere, overlooking the work in hand. That might mean overlooking your workbench or, if you're doing something more upscale, peering into, say, that washing machine, engine bay – or whatever.

This set-up means you need only press the shutter release at key points to record the project. It also means you don't have to grab your camera with greasy or dirty hands. Remember, too, that as you're shooting digitally you can shoot every stage – and it's better to do so than to shoot too infrequently. When it comes to reassembly, remember to view the photos in reverse order.

CLEVER IDEA 16:
REMEMBER A NUMBER

There was a time that, when you saw a number of interest on a notice board or amongst small advertisements in a shop window, you would need to note it down and call when you got home. Now, of course, you can call from your mobile phone straightaway. But if you want to keep a record of the advertisement for calling later, a quick shot with your camera records it all.

Scanning ads: a quick snap records all the crucial information on a notice board for you to review at your leisure

SENSECAM, THE VICON REVIEW AND ALZHEIMER'S

Some years ago, Microsoft Research in Cambridge, UK, produced a camera called SenseCam. Rather than the user actively shooting photos, the camera, worn on a neck strap, automatically shot photos all day long. It has now been adopted by Vicon Motion Systems as a commercial product. Worn continuously, the user can replay the images – via a computer – at the end of the day.

So, what's the point of this camera, and why discuss it here? Well, in addition to being used to create rather prosaic time-lapse movies that have naturally made their way on to YouTube, it has been used extensively for those with severe memory loss conditions including Alzheimer's disease. In tests, patients with memory impairment from the disease have seen improvements of up to 80% in recall.

Total recall: the diminutive Vicon Review camera can record images of the wearer's life throughout the day

All in a day's work: for people with memory impairment, sequenced images like this – although dull and of no photographic merit – can prove invaluable

CLEVER IDEA 17:
RECORD COLLECTABLES

Even if they have little intrinsic value, collections of coins, stamps, medals or even jewellery clearly have value to you – that's why you collect them. Taking photos of them helps to share your enjoyment with others: you can show them off more easily at clubs and societies, or they can form the basis of a website.

SHOOTING COINS AND STAMPS

Coins and stamps – and other collectable ephemera such as rail tickets, banknotes and even sporting programmes – have one major advantage when it comes to photographing them: they are flat. This makes it easy to focus on them and to get the often-small subjects critically sharp in the shot.

Unless you're shooting something large – like a whole page of stamps – you need to get in close and focus close. This means selecting the macro mode on your camera. Virtually every camera has one of these and it simply reconfigures the lens for focusing close up; you also need to shoot your subject square to avoid distortion.

TIP

The easiest way to shoot your subject square is to invest in a mini tripod or similar support that will hold the camera level to your album or display pages.

WATCH FOR REFLECTIONS!

With reflective subjects such as coins or even some jewellery, it's all too easy to capture a distracting reflection from the camera's flash. To avoid this, ensure the flash is switched off when you're shooting these.

Collectables: items such as stamps and coins are easily photographed

SHOOTING JEWELLERY

The technique is much the same for shooting jewellery, except you are likely to have a wider range of shapes and sizes to accommodate and most objects won't be as flat as coins and stamps. If the items you intend to shoot come in a display box, then why not use that? It's designed to show the objects to best effect. For rings, you'll generally want to record the stone, so that's the part you need to focus on. It doesn't matter if the band is out of focus.

CLEVER IDEA 18:
SHOOT TABLE-TOP SCENES

Models and miniatures: shoot models at low levels to achieve maximum realism

You can shoot a table-top scene not only as an obvious model (usually from above) but also with added realism, so it almost appears to be a real, full-scale scene.

To achieve this added credibility you need to position yourself at ground level, in amongst the action. Set the camera's zoom lens to its wide setting for best effect; this will also ensure that you keep the maximum amount of the scene in focus. If your camera will allow it, select a small aperture as this will further enhance the amount of the scene – from nearby figures or buildings through to more distant items, in table-top terms – that is sharply defined.

CLEVER IDEA 19:
TURN THE REAL UNREAL

Before and after: TiltShiftGen is a downloadable piece of software that narrows the in-focus range of a photo to produce the effect of a small-scale model

Here's an intriguing technique to turn reality on its head, by essentially taking shots of the full-scale world and then making them appear as miniature-scale, Lilliputian scenes instead. Users of camera phones are at a particular advantage here as there are applications you can download – very cheaply – that allow you to manipulate the depth of field in your scenes with virtually infinite variation.

Depth of field is the amount of a scene – level with, in front of, and behind a subject – that is in sharp focus. Normally the depth of field is quite broad; in landscape shots, for example, it may extend from a metre or two in the foreground to the distant horizon. These applications allow us to reduce depth of field to a very narrow amount, thereby creating an effect similar to that your camera would produce when shooting a small, table-top model.

The skill when using these apps comes in determining what you keep in sharp focus and what you allow to become blurred, and by how much, so that you create a realistic impression of a small-scale scene. There's no right or wrong here; trial and error really is the best approach.

INVEST IN A MACRO LENS

Professionals who do a lot of close-up work – for example naturalists who photograph flowers, bugs and insects – tend to use special macro lenses. These specialist lenses are designed for recording small objects accurately and are often also telephoto lenses, which allow you to shoot close-up from a distance. These types of lenses are not prohibitively expensive and are well worth the investment if you have a digital SLR and are fascinated by the macro world.

CLEVER IDEA 20:
PHOTOGRAPH CHILDREN AND PETS

With his famous quote 'never work with children or animals', W.C. Fields has forever applied similar attributes to both. Ironically, despite his stage persona, Fields was very fond of children; whether he was also fond of pets is not known. Nevertheless, when it comes to photographing children or pets you'll find them equally uncooperative and utterly charming in equal measure. So you need to know how to – photographically at least – coax the best from them. Here are ten top tips to help you get going:

- **Have patience:** Patience is certainly a virtue when it comes to shooting children and animals. Unlike other subjects, they won't play to the camera and are more likely to want to play with you.
- **Get the level right:** Shoot children and pets from their eye level; shots of children in particular, work better taken at their level. Be prepared to crouch or even lie down to shoot – this is probably where you wish, if you don't have one, you had a camera with a fold-out viewing screen to let you shoot low from a more comfortable position.
- **Go for the eyes:** Whatever your child or pet is doing, make sure you focus on the eyes. That's where we all tend to look first in any photo and lack of sharpness in this area will ruin the shot.
- **Bribe them:** Or give the dog a bone... Have treats and favourite toys on hand to capture attention or encourage behaviour. Having a second person on hand can help, too, allowing you concentrate on getting the winning shots.

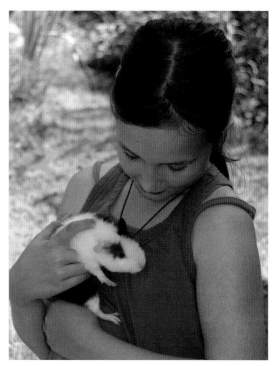

Children and pets: combining children and pets can make for some enchanting photos. Is the child a prop to the pet, or the pet to the child?

- **Frame your shots:** Whether you are shooting a head-only portrait or the whole subject, using a medium zoom setting (or medium telephoto) will achieve the best results. Avoid wide-angle shots that can distort features and create that 'back of a spoon' look.
- **Blur the background:** This is the same advice you'll get for all portrait-type shots. Give the child or pet greater emphasis by ensuring the background is blurred. If you've set the camera lens to a medium zoom, as mentioned above, you'll be well set for this result anyway.

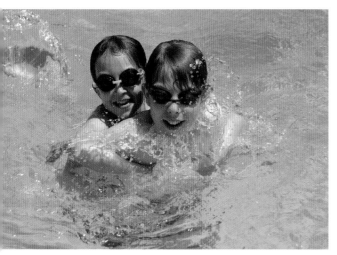

Children playing: getting children to pose can be problematic, so why not capture them doing what they like best?

- **Shoot outdoors:** If you can, shoot outdoors in light, overcast conditions for best results. If conditions are brighter you can often lessen shadows by turning on the camera flash; select the fill-flash, or fill-in flash setting if your camera has multiple flash modes.
- **Avoid using flash alone:** If shooting indoors or in very dim light outdoors, try to avoid using flash. The light from the flash can often reflect from the subject's eyes giving the characteristic 'red-eye' appearance in children or 'green-eye' in cats and dogs. Not at all flattering.
- **Vary your shots:** Go for facial close ups, whole body shots, action shots and more.
- **Use adults as props:** If your child or pet just won't behave, why not use adults as props? Have brothers, sisters and parents interact with the subject. Ask owners to cuddle their pet or make it do something characteristic like running over their shoulders or standing on top of their head. All make for great shots.

Looking up: it's usually best to shoot children from their eye level, but try moving below to get shots that make the children look more confident. Similarly, shooting children from above can make them look subservient

GO FOR CLICHÉS

We've all seen those photos of kittens in shoes, gift boxes and the like. They may be a bit too cute but props like these can be great for getting your pet to stay in a good posed position. Break the mould by choosing some imaginative props and making sure these props – like the pet – are photogenic. Or go for caricatures: shoot with the camera's zoom set to wide angle to deliberately exaggerate your pet's features. This works particularly well with puppies – I would challenge anyone not to find most puppies loveable when shot in this way!

Break the rules: shoot pets with wide-angle lenses or lens settings for this surreal but loveable look

CLEVER IDEA 21:
SHOOT A PRODUCTION DRESS REHEARSAL

If you enjoy open mic night at the local pub, are a devotee of amateur dramatics, or simply want to record a school musical production, why not take your camera along? Many of us do just this, but come away with a disappointing collection of photos. Let's look at some ideas to help get something better.

If you want to shoot a play or concert, ask to attend a dress rehearsal. Without the paying audience you'll have greater freedom and will be able to move around relatively unhindered. Of course, you still have to be mindful of directors and other production staff who may not want you getting in the way too much... Assuage this by offering to donate some of your brilliant photos for publicity.

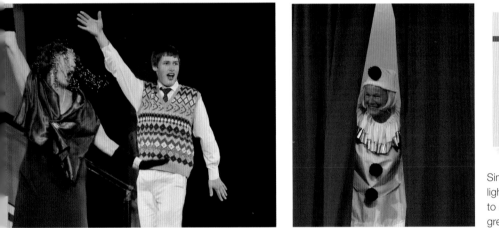

> ## TIP
>
> Set the camera to auto sensitivity if you have this option; it will help you to get the best results as the light levels vary.

Simple snaps: with good stage lighting you can set your camera to auto mode and take some great shots straight away

CLEVER IDEA 22:
BECOME A PRODUCTION ASSET

As someone who has shot a fair few major productions, I am well aware that many performers are surprised by the way they appear on stage in the production's photos. And as these images tend to come to light just ahead of the full performances, it can be a little unnerving for them. Repay the favour of being granted exclusive access to a rehearsal by letting the performers see how they are doing as they go along.

Why not show the performers your shots of the production during the interval? Or, shoot movie clips to replay to them. This can prove a great icebreaker as those involved in the performance realize you can be an asset to the show. That can even mean you'll find the performers will act up to you, providing you with even better photos. You might even find yourself becoming something of a roadie!

CLEVER IDEA 23:
SHOOT CAST PORTRAITS

As well as shooting photos and video to show performers how they are doing, why not shoot some portraits too? Visit a London show, or even a regional pantomime, and you'll see portraits of the cast members and scenes from the show as you head in to the auditorium. Smaller troupes and bands can rarely afford to commission a photographer for this, so why not offer some of your best shots to them for their publicity? You could even arrange to take some in-character portrait shots.

Showtime: shooting amateur performances is not difficult and can deliver some great photos. If the cast includes family members the results are even more memorable

TIPS FOR GREAT STAGE PHOTOGRAPHY

Here are some more great ideas and tips for getting the best from stage photos:

• **Set your camera's sensitivity high:** The low light levels can inevitably lead to exposure times that are long, so crank up the ISO speed of your sensor to ensure photos are as sharp as possible.

• **Use available light:** Don't use flash. It will destroy the atmosphere and could well result in your removal from the performance.

• **Go for character close ups:** Although the urge may be to go for great ensemble shots, don't forget to zoom in on some great facial expressions.

• **Use the exposure compensation feature:** If your camera has exposure compensation, try selecting underexposure to preserve the lighting effects on stage. That way you'll maintain as much of the atmosphere of the original scene as possible.

CLEVER IDEA 24:
LEARN THE ETIQUETTE

A theatre show, a musical, an opera, or a rock concert can be the culmination of many months, perhaps years, of preparation. That's why, if you want to get some great shots or any shots at all, it pays to follow a few simple rules of etiquette:

- **Plan ahead:** Ask in advance about attending. Don't simply turn up at the stage door and expect access.
- **Discuss your shoot with the manager:** Let the stage or venue manager know what you plan to do with the photos. If you have a commercial use in mind (for example, selling your photos) you may face restrictions.
- **Follow safety and other instructions:** If you are permitted to take photos, follow any directions or restrictions.
- **Don't shoot where prohibited:** Copyright laws prevent you photographing some commercial productions.

CLEVER IDEA 25:
SHOOT SPORT AND ACTION

Some photographers say that when it comes to sport and action photography, it's more about luck than experience. That's arguably true, but with a little technique you can capture some really impressive shots of your favourite sport or activity that would not be possible with luck alone. You certainly have to be fast to capture the best shots of sport and other action – here are some great ways to get the best results every time:

- **Shoot plenty:** Here we are saying it again. Pro sports photographers talk about 'the decisive moment' – a fleeting composition of the critical moment of action. This can be hard for most of us to spot and, once spotted, it will inevitably have passed by the time you press the shutter. Shoot several shots in succession and you've increased your chances of capturing that perfect one.

- **Choose fast shutter speeds:** If your camera has the option, select shutter priority and the highest shutter speed your camera will permit. This will help freeze fast action and limit any chance of blurring.

- **Get the focus right:** With subjects that may be moving fast across your field of view, or moving rapidly towards or away from you, it's crucial to keep them in focus. Make sure, if your camera has a follow focus control, that it's engaged. If not, apply a repeated, light pressure on the shutter release button to prime the camera ready for action by ensuring the lens is just about focused every time you shoot for real.

- **Move in close:** It's not always practical to do so physically, so use a telephoto lens or the telephoto end of your camera's zoom. When shooting sporting events in particular, you can be disappointed to find the key action is almost indiscernible in the centre of the shot. Zoom in, remembering as you do so that your camera will be more liable to shake so make sure you've double checked it is set to the fastest shutter speed possible.

- **Learn to follow the action:** With fast-moving subjects, don't keep the camera fixed and shoot no matter how fast the shutter speed. Instead, learn to use the camera to follow the action and press the shutter while still tracking. This way you may get a blurred background (no bad thing when inferring action) but the subject will be sharp.

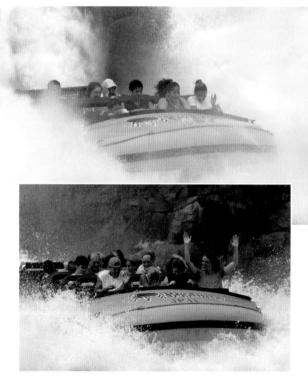

Fast action: you'll often get sharper shots of fast-moving objects as they move towards the camera. Many cameras now predict movement and assess the focus the instant you press the shutter release

- **Know your event:** If you're shooting a sporting event, a basic knowledge of the sport will help you assess the best positions from which to obtain the best shots. If you are not an expert take a look at where the press and pro photographers stand. No pro photographer shoots successful football shots, for example, from way up in the stadium seating; they tend to be at the player's level, close to the pitch.

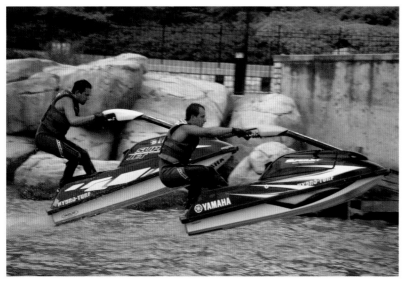

Faster action: for subjects moving left to right (or right to left), follow with the camera to ensure the subject is in sharp focus. The blurred background only adds to the sense of speed conveyed in the shot

CLEVER IDEA 26:
GET IN ON THE ACTION

We've been talking so far about shooting sports and action as a spectator. However many sports and activities present great photo opportunities for those actually taking part. So why not take your camera with you next time you head off for your favourite sport? Here's some ways of getting in on the action – with your camera:

- Mount your camera on a helmet (use a proprietary mount, or strong tape) or strap it to your chest. Get familiar with where the shutter release is located so you can shoot blind.
- Mount your camera on cycle handlebars, again using a proprietary mount or something more improvised.
- Invest in a headcam, that you will be able to buy relatively cheaply. They come with an elasticated headband, perfect for those eye line shots.
- Tape your camera to a model train or car. You'll need a remote release to take your shots, or set it to record movie footage before heading off.
- Shooting photos while taking part is not always possible for safety reasons; never compromise safety for a great shot.

Headcam: take part in the action and capture some great action shots at the same time with an inexpensive head camera like this

CLEVER IDEA 27:
MATCH COLOURS WITH PERFECTION

Have you seen a fantastic colour that's perfect for your home décor? Or some fabrics you want to colour-match? Grab your camera, take a shot and you have a perfect record of your perfect colour. Or so you might think. In fact, digital cameras aren't precise in the colours that they deliver. They are close, but not spot on. Light changes, shadows, the camera itself – all of these factors introduce subtle shifts in colour. Often these shifts are so slight that we don't notice. And, for a typical photo, does it really matter if the sky is a touch different in hue to the real sky? Perhaps not.

PERFECT COLOUR MATCHING

However there will be times when close – in colour terms – is not close enough. Take the example we started with: you want to colour coordinate your home. You have a lovely piece of furniture and want to find a paint that perfectly matches its colour. You take a photo, print it out, and take it to your paint store. You match it up with a paint and – job done. But when the colour goes on the wall you realize it's actually not the same as the furniture at all.

To tackle this problem we need a way of getting our camera to identify colours – not approximately, but perfectly. And here it is: this small sheet of card known as a colour checker, printed with an apparently random grid of colour swatches with a rectangular hole in the centre, is our salvation. This – or something similar – is available from most paint mixing companies.

To get that perfect colour match, place this sheet firmly over the colour you want to match and take a photo. Upload the photo to the paint company's website and they'll advise you of the nearest matching colour, or even mix an exact match for you. This time you can be certain you really do have an exact match.

Colour coordination: colour matching can be problematic but grab your camera to help you get it spot on

> ### ⓘ COLOUR MATCHING: THE PRO SOLUTION
>
> Have you ever wondered how professionals manage to match paint and fabric colours precisely? To do this they actually use a potent piece of kit called a spectrophotometer. Using a sample of the coloured material small enough to be loaded into the device, a precise light source analyzes how light of different wavelengths is reflected, building up a precise colour profile of the sample which can then be used to determine what pigments need to be used to recreate that colour in paint. Accurate, but no use if the sample colour is firmly affixed to a wall, located in someone else's home, or on public display.

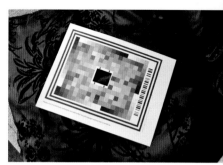

Paint grid: the careful arrangements of precise colours will help you to analyze and determine the exact colour of anything in the central cut out

> ## ⓘ HOW DOES IT WORK?
>
> The secret is in the pattern of random colours surrounding the hole. Although they appear random, they are all precisely defined colours that the computers at the paint centre can determine precisely. Once these computers have calibrated these colours, they can assess the precise colour of your sample. From this, an exact match paint colour can be produced.

CLEVER IDEA 28:
USE WHITE BALANCE

To avoid poor colour rendition, digital cameras have a control known as white balance. In essence, this makes sure that – as far as possible – your camera reproduces colours as accurately as it can. But the control needs to know what conditions it's shooting under.

Although we don't realize (because our eyes are remarkably adept at compensating) all light sources add a tint to objects viewed – and photographed – under them. The white balance control lets you neutralize any colour cast so that it appears as if it were shot under pure white light.

Fortunately most cameras have a white balance control that can be set for different lighting conditions – whether daylight, bright sunshine, tungsten lighting, and so on. Setting this appropriately will give you the best results in the available light. There's also an auto setting for white balance that is a good setting to choose if you're in a situation where the lighting is mixed.

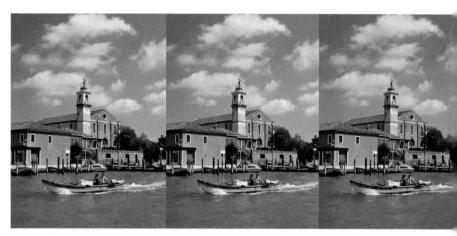

White balance: one scene, three white balance settings – it's important to match the white balance setting to the lighting in the scene. In this case the auto white balance setting (left) makes a great job of accuracy

LOCATING THE WHITE BALANCE CONTROL

If your camera has a white balance control you'll either find it in a menu or via a press button. There's no real consistency in the ways that different manufacturers deploy it, so it might mean a trip to the user manual. But to achieve the best colour quality possible in your photos, it's certainly worth spending the time to locate.

CLEVER IDEA 29:
APPLY SIMPLE EFFECTS – FAST

Using simple photo effects can transform an ordinary photo into something quite impressive. OK, so you probably won't be able to transform a mediocre picture into a real winner, but you can often give a good picture an extra lift. Here's some great examples of effects you can quickly apply:

TRANSFORM YOUR PHONE IMAGES

You can apply a huge range of special effects directly to shots taken with your phone camera. You will need to download appropriate apps to your phone to do this but don't worry; most of these are either free or low cost.

For aged photo effects, try out these:
• Hipstamatic
• Instagram
• PhotoToaster
• OldPhotoPro

For artistic effects, try out these:
• Mobile Monet
• Oil Painting Effect

This list is not exhaustive and, no doubt by the time you read this, there will be some great new ones to try out too.

TIP

The good thing about these apps is that they apply an effect to an image and then, if you like it, you can save a copy – your original image is unaffected, letting you apply another effect as and when required.

Effects preview: many apps let you preview special effects – along with any variations – before applying

SPECIAL EFFECTS

Using PhotoToaster, here are some examples of what you can do – often with just a couple of touches – to images to transform them:

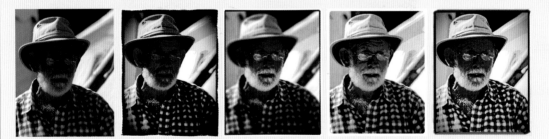

Portrait: although the original was a great portrait, the special effects give it a slightly different – excuse the pun – character

FOR BEST EFFECT...

Make sure you match the effect to the subject. Old sepia toning effects work best with photos of old buildings or historic scenes. Bright, Technicolor effects work best with bold, brashly coloured original scenes.

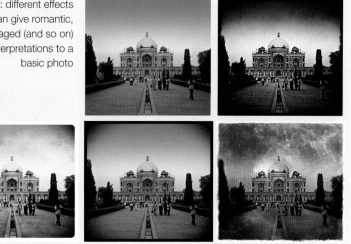

Tomb: different effects can give romantic, aged (and so on) interpretations to a basic photo

APPLYING SPECIAL EFFECTS IN-CAMERA

Some camera phones allow you to apply special effects – sepia tones, black and white treatments, vivid colours, and so on – directly as you shoot with your camera. This means you end up with photos that have the special effects already applied. This sounds like a great shortcut, but sadly it's not. What if you want to change the effect, or use the straight, unadulterated image? You're stuck; what you've got is for keeps. It's always best to shoot the images without effects and apply them after.

TRANSFORMING CAMERA IMAGES

If you shoot your photos with a camera – rather than a camera phone – you'll normally need some software to transform your images with effects in-computer. Don't worry, though. Image-editing applications have a reputation for being complex but there are simpler applications available that quickly apply effects such as those shown here. Give applications like Photoshop Express and FxFoto a try and discover how easy it is to create art from your photos.

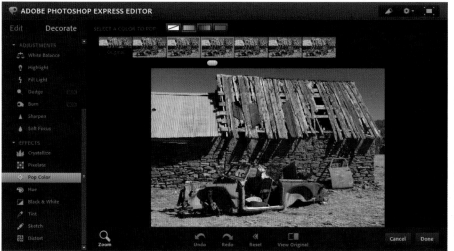

Photoshop Express: stable mate of the lauded Photoshop, Photoshop Express is a quick way to edit your camera images – and lets you share your transformed images

CLEVER IDEA 30:
TELL A PHOTO STORY

Visually we tend to think of video and movies as the media for telling stories. But photos arranged in sequence can also be used to tell them, too. Indeed, in the early years of photography there were no movie options and so photo storytelling became something of an art form. Some of the greatest photographers create photo stories – or photo essays as they are sometimes called – and the result is far more compelling than the sum of their individual images. So how do you create a photo story?

TELLING A PHOTO STORY

The key to any photo story is, not surprisingly, a story. The story might be a day out, an important event, or a fictional tale you'd like to tell. So how does shooting a photo story differ from the normal photos you might take?

You need to think about the way stories are constructed. Normally they comprise an introduction, the main body, and then a conclusion. Generally, when we head off to any event or even away on holiday, the photos we take correspond to

PRESENTATION

Many would argue that a photo story needs no special approach when it comes to presentation – the photos should stand well together on their own. But you can present, publish and embellish your stories in many ways. A great website on which to publish your photo stories is Show Beyond (www.showbeyond.com). Here you can sequence (and re-sequence) your photos, and even add narration and music. There are also plenty of other photo stories to review for inspiration.

You could also opt for a more traditional approach, with a photo album or the digital equivalent, a photo book (see also **Create a Photobook**). A holiday photo book becomes much more memorable when compiled with a story approach, and most photo books let you add captions too. Or why not create a simple collage and add some captions? You can do this easily using image editing software – or even with glue and scissors!

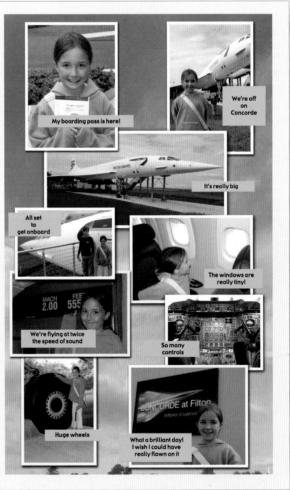

A day out: this simple story recounts a girl's day spent visiting a Concorde museum. Note the way that the captions here help to tell the story

that main body. At a wedding you'll shoot the ceremony and, perhaps, the reception. On a day trip to a theme park, for example, you'll take lots of shots of your friends and family on the rides and having fun at the park.

For a photo story you'll need to alter your approach slightly to shoot those introductory and concluding shots too. What might these be? For a day out you might include shots of excited children getting ready to leave, packing up the car, or an impromptu stop along the way for breakfast. You might also get some shots of signage pointing the way to the theme park. For the concluding shots you could get some great shots of tired children asleep in the car on the way home.

IDEAS FOR PHOTO STORIES

Almost any subject lends itself to this treatment – you just need to make sure you tell some sort of story. Here are some ideas to get you started:

• **A day out:** As described here.

• **A special event:** This could be a wedding, a christening, or special birthday party.

• **A friend or family member:** Recount the life story, or record the important years, of someone important to you.

• **A special place:** Tell the story of a day in the life of a special place. It could be a place of work, a park, or even your home.

CLEVER IDEA 31:
CREATE A PHOTO COMIC STRIP

Why not create a comic strip from your photos? This is a great, creative way to display your photos to unique effect. You can embellish your photo strip further by adding speech bubbles and other graphics.

There is software available that will help you do this. Here we've used a popular piece of software called Comic Life that makes this process easy. Simply choose your template from a wide selection of comic-style pages, then just drag and drop your photos into place and add speech bubbles as required. If you're using a camera phone you'll find apps that will create comic-style images to which you can add captions or even speech bubbles.

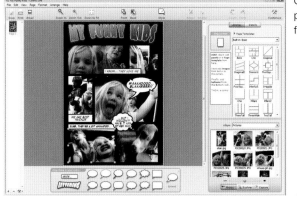

Create a comic: Comic Life makes it simple to pull images and graphics together to make a fun comic strip

Instant photo strip: photo strips like this are easy to create with Comic Life and make a fun, unique way of displaying your work

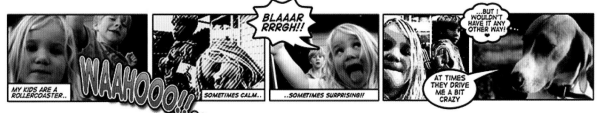

CHAPTER 2:
USING YOUR CAMERA OUT AND ABOUT

A camera probably figures pretty highly in a list of essential kit when travelling, heading off on holiday or even spending a day out. It is perhaps less likely to do so when heading off shopping, or doing other more mundane day-to-day duties. That's something of a shame because there are quite a few opportunities to use a camera on even the most pedestrian of outings.

In this chapter we'll explore some of these. Some might be obvious; others less so. For some you

might just think 'why didn't I think of that before?'. Now that many of us carry camera phones almost every waking hour there's no excuse – you can have a go at many of these ideas.

We'll also look at some cunning photographic ideas too; ways to make your photos that little bit better without that much effort. And what about a camera as a safety device, something to come to your aid in the most difficult of conditions? Yes, there's even a clever idea for that!

CLEVER IDEA 32:
GET INSPIRED BY POSTCARDS

Inspiration can come from strange places – and the store selling postcards for tourists can be one of them. If you want to get the best photos of any tourist location you're visiting, a shop or kiosk that sells postcards can provide terrific inspiration. How? Well, postcard printers want postcards that sell. And postcards that sell are those with the best views.

So, from a quick scan of the images that are on display you can quickly establish which are the best views and get ready to emulate – or improve – on them. You could even buy a few of the best to take along with you to make sure you really do shoot from the best location and viewpoint.

Inspiration: postcards may feature many clichéd views, but they can also be the most impressive

CLEVER IDEA 33:
HOP ABOARD A SIGHTSEEING BUS

City sightseeing buses are an excellent way of getting your bearings and, if you take the top deck, some great shots. OK, taking photos from a moving platform is not ideal, but you can still get some good shots to give your photo album a kick-start. And a sightseeing bus is probably the best way to get to see all the main landmarks and tourist hotspots in the shortest time.

If you want to be a bit more efficient about what you shoot, why not use your first circuit to gather ideas? Make a note of all the great places to shoot photos – using your camera as a visual notebook if you like – and then return to capture those winning shots.

TIP

The tickets on most sightseeing buses are valid for one or two days. This is ideal to let you jump on and off at all those great tourist spots and spend as long as you like getting the best collection of shots.

MIND THE FAMILY!

Families are sometimes less than impressed when the enthusiastic photographer among them spends what seems to be an interminable amount of time composing the best shots of each location visited. Using a sightseeing bus is a good way to avoid this problem and to ensure you get the top shots of your city tour. At the sam e time, the family can enjoy experiencing the tour and sights.

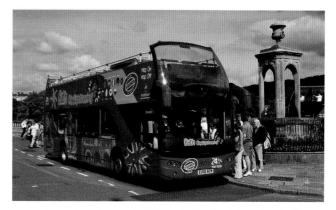

Jump aboard: you might be jostled by tourists, but a circuit on a sightseeing bus can be the ideal way to get some great city shots

CLEVER IDEA 34:
SHOOT THROUGHOUT THE DAY

TIP

Look out for tourist maps – and even some guidebooks – that point out the best spots from which to shoot.

Faced with a new city or country we can become a bit overwhelmed when it comes to photography. As soon as we see those dramatic landscapes and tourist hot spots, we can tend to shoot away without a second thought for the pictorial value of the photos. It's only later, when we come to view the photos on our return home, that it becomes obvious that we could have done better.

Taking account of varying lighting conditions can make all the difference to the quality of your pictures. For example, light conditions will usually be brighter around midday, but the shadows at this time can be unflattering to both people and the landscape. You'll get the very best results the hour or so before sunset, and the hour or so after sunrise, when there are much warmer colours and more interesting shadows.

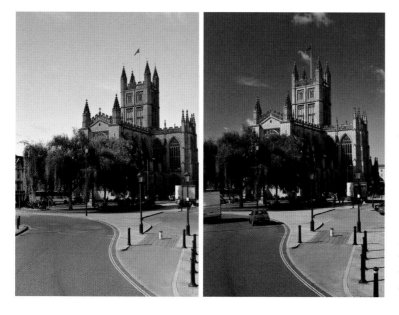

Revisiting locations at different times of day is recommended to capture these varying lighting conditions – areas that are in shadow in the morning may be in direct sunshine later in the day. And those landmarks in silhouette because the sun is behind them in the morning, will be utterly transformed when lit by afternoon sun.

Good lighting: this is essential to getting the best from a scene. The light can vary dramatically throughout the day; here are two views from the same position taken just 15 minutes apart

CLEVER IDEA 35:
SHOOT THE ORDINARY

Now this idea sounds as if it could be dull, but photos of your home, your town or village, or even your local shopping district could be more compelling than you think. A while back I was drawn into watching a family slide show. It was one of the old-fashioned kind that involved a slide projector, drawn curtains and a worryingly large collection of slides relating to events in the town reaching back to the 1960s.

As so often happens at such gatherings, people watched politely as a few members of the audience recounted the stories associated with each event. But then something strange happened. As some more general photos were shown – of the town itself – the level of interest increased and suddenly virtually the entire audience was engaged.

WHAT TO SHOOT

To capture an engaging record of your location, shoot the mundane as well as the interesting. Shoot the old and the new – it's surprising how quickly new buildings become weathered and accepted as part of the landscape. Stores and store windows are also good subjects. How many, sometimes major, stores that were once the mainstay of a high street have gone out of business in recent years? There's no telling what might go the same way in the years to come.

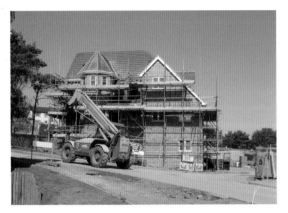

HOW TO SHOOT

There's a popular book called *Boring Postcards* that features just that – boring postcards. It comprises views of bus stations, roundabouts and the like. But there's no reason why your photos should present themselves as candidates for a future edition. You may be shooting subjects that some might not consider photogenic, but that's no excuse for the photos themselves to be mundane.

> **TIP**
>
> Concentrate on areas that are subject to development. They may seem tired and ripe for urban renewal but, once such redevelopment has taken place, those old views will be lost forever.

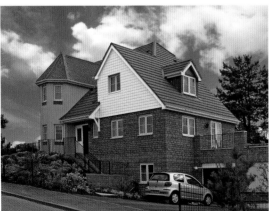

Recording change: cataloguing changes in the landscape makes for great conversational photos – often many years after they were taken

Cutty Sark: a pretty ordinary shot of the bow of the ship; a year later much of it was destroyed in a devastating fire

Old store: when this store disappears, photos will be all that remains of it

CREATE YOUR OWN PAST AND PRESENT BOOK

There are plenty of books that compare photographs shot in Edwardian days with those shot in the same location today. If you've access to a collection of old photos of your area, why not team up and take your own corresponding 'present day' shots? It may not get published, but you could create your own photobook or hold an exhibition in a local village hall or library that will be of real interest to locals.

CLEVER IDEA 36:
COMPILE A VISUAL DICTIONARY

What use could a visual dictionary be? Well, just think about it for a minute. You're travelling in a country where you have little command of the language; it may not even use the Latin alphabet. You need to find a railway station, restaurant, or even a toilet. Relying on local signage can be fraught with difficulties and result in embarrassing faux pas, but with a quick look-up set of images of the same you can easily ask for directions.

A VISUAL NOTEBOOK

Why not try recording interesting menus and restaurant information as you travel? When you're exploring a new city you can enter a period of sensory overload with so much to see and so much to take in all at once. It's easy to see something enticing, like a brilliant restaurant, and not be able to recall the details later. So, as well as taking a shot of the restaurant itself (ideal for showing taxi drivers), shoot the menus, too. Then you can review them at your leisure before setting off to eat. This idea works just as well for other useful information – museum opening times, for example.

Can you direct me… to a coffee shop, a bank or a restaurant?: a visual dictionary makes it easy

CLEVER IDEA 37:
BOOST COLOUR... WITH YOUR SUNGLASSES!

If you've ever scanned through those glossy travel magazines, you can't fail to notice how they make every location look colourful and sundrenched. The rich blue skies, azure sea and dazzling bright sands make you just want to be there. Does it really look like that or has some digital sleight of hand been used to embellish the colours? No, there's probably a much simpler reason for this appearance: the photographer has used a polarizing filter.

Part of the standard kit of a travel photographer, this filter is a prized accessory that helps accentuate and deepen colours. Unfortunately few compact cameras are designed to accommodate a polarizer and, for those cameras that do have this facility, a good one can be pretty pricey. But if you want to emulate these photos, the answer could already be in your hands. Or – more accurately – on your head.

If you have a pair of Polaroid sunglasses – and they must have real polarizing lenses, not just tinted ones – you can use them as a polarizing filter. Just hold them squarely over the lens and shoot. You can use the camera's LCD screen to preview the result. Stand by for some great colour-enhanced shots!

Shooting through the lens of Polaroid sunglasses creates deeper colours in your photos. It will also remove reflected light; check out the reflections in the windows in these two images

POLARIZING TIPS:

- This technique only works when shooting in sunny weather. You just won't get the same effect when it's cloudy.

- You can get different polarizing effects when you turn the sunglasses relative to the camera. To see this, take a look through the glasses first and then turn their lenses until you see the strongest polarizing effect.

- Strong prescription polarizing lenses tend to affect image quality, but experiment away – you can still get some great effects with them.

(I) HOW DOES IT WORK?

How does a polarizing filter – or sunglass lens – deliver these vibrant colours? Without going into the science, it is reflected light that tends to tone down or slightly wash out colour; polarizers remove this reflected light from a scene.

Reflected light itself is polarized so, as you pass it through a polarizing lens of some sort, it is cancelled out, leaving brighter, more vivid colours.

When you turn the lens of your sunglasses relative to the camera and scene, you reduce and enhance the amount of reflected light that is cancelled out. This is why the effect can be varied.

Spot the difference: polarizing filters can make a real difference to image quality

SHOOTING THROUGH GLASS

Ever find yourself taking photos through glass, a store window or a car windscreen? Put your polarizing sunglasses into use again; they are brilliant at removing distracting reflections.

Trick of the lens: using a polarizer not only removes reflections from glass – it can do the same for water. In this image the polarizer makes these boats almost look as if they are floating in thin air!

CLEVER IDEA 38:
SHOOT LANDSCAPES

Landscape photos can be seen as clichéd and are often not very inspiring, however they continue to be a great favourite of many photographers. This is understandable; we all have access to landscapes and it's something of a challenge to record these beautiful subjects successfully. By following a few simple guidelines, you can produce some real stunners of your travels:

- **Keep it sharp:** If you select your camera's landscape scene mode this will automatically configure your camera to ensure optimal focus. If not, select a small aperture to ensure just about everything in the scene will be in focus. Landscape photo experts advise focusing the camera in the middle distance, rather than the most distant points, to obtain the widest range in focus.
- **Keep it steady:** The camera, that is. Cameras set to small apertures and lower light levels can conspire to produce long exposure times. Use a tripod or a firm support (brace your camera on a wall, for example) to ensure pin-sharp results.
- **Compose carefully:** Look at your LCD preview screen before shooting. Ensure the horizon is level and doesn't cut the scene in half; place it one-third or two-thirds of the way down the frame to create a stronger composition. Ensure there's a subject of some kind in your shot, whether it's a near-distance stone or flower, a middle-distance waterfall, or a far-distance peak. It provides viewers with something to focus on.
- **Shoot throughout the day:** On a bright, sunny day you'll get some good landscapes. Shoot in those golden hours before sunset or after sunrise and you'll get

some fantastic shots. Actually, shooting the same scene at different times of day can lead to some great comparison shots; it's amazing the difference lighting can make to the subject and the finished result.
- **Watch the weather:** Don't restrict your landscapes to the summer sunshine. Winter scenes with brooding clouds, layers of fog and mist, and snow and ice all lend a different, but no less beautiful, appearance to the landscape.
- **Try a polarizing filter:** If your camera can use one, a polarizing filter can help enhance colours and remove reflections – particularly from water. Not to be used in every shot, but a great way of pepping up those colourful coastal scenes.
- **Don't shoot in landscape format alone:** Conventional wisdom suggests that landscape photos should be shot in landscape format – but don't believe it! You can compose some great landscape photos in portrait format too. Rather than the sometimes-bland sweep around the horizon, in this format you can take in objects from close up to far away.

Sunset: as the sun sets you can get some great monochromatic effects like this

Focal point: give your landscape a focal point, somewhere that attracts the viewer's attention first

THE ROADSIDE DOESN'T OFFER THE BEST LANDSCAPES

Well, only very occasionally. For the best landscape subjects you may need to get off the beaten track and, mindful of your safety, explore the wilderness. Large-scale maps will often help, highlighting trails, pathways and beauty spots.

Upright landscapes: don't limit your landscape shots to landscape format – some subjects just beg to be shot in upright, portrait format

CLEVER IDEA 39:
GO URBAN FOR SOME GREAT CITY PHOTOS

If you find yourself in a big city, don't feel you can't shoot some great landscapes. There are as many great shots in the city as you'll find in any wilderness; here are some clever ideas for shooting the city:

- **Shoot throughout the day:** Early in the morning you can see the city coming to life. It's also generally cleaner then and the roads will have less traffic. In the evening the city lights up with beautiful colours and you can get some great shots as the sky darkens.
- **Shoot from different angles:** Tight, confined spaces in many city centres – and back streets – make it hard to shoot strong images with the camera held conventionally. Point it up, down or at odd angles to create much bolder images of even familiar subjects.
- **Avoid boring roof scenes:** Get up high and you imagine you can shoot sweeping urban vistas. However, look at those shots afterwards and often all you have are bland views of rooftops.
- **Shoot old and new:** Cities evolve architecturally; if you shoot buildings of all ages you will end up with an intriguing mix of architectural styles that add interest to your images.
- **Shoot the details:** Details – as well as sweeping urban scenes – make great photos and convey just as much about the city.
- **Don't forget people:** Cities are where people live and work. Don't deliberately exclude them from your photos as people add scale and character.

Old and new: the juxtaposition of the old and new makes for great shots

Abstract: zoom in on details to capture some abstract shots

CLEVER IDEA 40:
USE LOW LIGHT FOR ATMOSPHERIC SHOTS

When the light dips most of us tend to pack away our cameras, thinking the dim light unfavourable. The good news is that cameras today are sensitive enough to make the most of these conditions and are able to capture some incredibly atmospheric images.

BASIC LOW LIGHT PHOTOGRAPHY TIPS

- **Use a support:** Low light levels mean longer exposures – and that means the risk of camera shake. If you don't like the idea of carrying a tripod everywhere with you, look for impromptu supports (see **Become a Sharper Shooter**).

- **Use the camera's self-timer:** Using the self-timer to trigger the shutter instead of your shaky hand is a great way to avoid camera shake on those longer exposures. On a firm support you can take your hands away completely to avoid introducing any kind of vibration.

- **Use the night portrait scene mode:** If you've someone or something in the foreground of your shot, you could consider using the night portrait scene mode, featured on many cameras, to add a burst of flashlight to illuminate the foreground subjects.

- **Don't rely on your camera's LCD panel:** The LCD panel on the back of your camera normally delivers a pretty authentic view, but it can be fooled at low light levels, displaying the scene brighter or dimmer than the actual shot. Get to know how your screen over- or underestimates – and check the post shot view as well.

- **Check white balance settings:** Cityscapes at night and at dusk have a mix of fluorescent, tungsten and energy saving light sources that can confuse your camera's white balance setting. Try both your auto and tungsten light settings and then choose the best option for your shot.

- **Bracket your exposures:** Bracketing simply means taking the same shot with different exposures. After you've taken a conventional shot, set the camera to shoot at different exposure settings by altering the exposure compensation dial or setting manual controls. Then you can choose the best result and use those settings for future shots.

NIGHT AND LOW LIGHT TIPS FROM THE PROS

- **Exploit the digital advantage:** Night and low light photography with digital cameras is easier than with film cameras. They can handle the lower light levels better and you can see the results right away. You can also change the camera settings if need be.

- **Underexpose to enhance colour:** Left to their own devices, cameras won't realize you're trying to take evening or night shots and will try – rather like a faithful dog trying to please its master – to deliver you a bright, well exposed shot. That's not what you want, so set exposure compensation controls to deliberately underexpose.

- **Use the aperture priority mode:** If your camera lets you select the exposure mode, choose aperture priority (often marked 'A') and select a small aperture. The exposures will be longer but you'll get more pleasing, sharper results, often with bright lights turned into twinkling stars.

- **Select a modest – or lower – ISO sensitivity setting:** Some cameras today can shoot at absurdly low light levels but in doing so introduce electronic noise that makes the photos look grainy. If your camera does this, switch from 'auto ISO' to a fixed ISO – of say 400 or 800 – and use this.

Enhanced colour: the automatic exposure (inset) is somewhat less colourful than the enhanced shot that was achieved by setting the exposure compensation to deliberately underexpose

Night scenes: views like this are surprisingly easy to capture with a digital camera. As exposures tend to be longer than can be successfully handheld, it pays to either use a camera support, or to make use of your camera's self-timer

Ice rink: light levels at some night events are sufficiently high to allow conventional exposures

CLEVER IDEA 41:
GET ATMOSPHERIC SHOTS INDOORS, TOO

Get the best from your camera indoors, too. Avoid those shots with murky dark backgrounds and bleached out subjects by using these simple tips:

- **Use a wide angle:** To get the best from interiors use a wide-angle lens or a wide zoom setting. Not only do you capture more of the interior, better capturing the atmosphere, you achieve better perspective on your subject, too.
- **Keep the camera level:** This will help you to avoid distortions – or apply a very obvious tilt for wild, exaggerated distortions.
- **Open wide:** Wide-angle lenses – or settings – allow more of a scene to be in sharp focus with a large lens aperture. This is great for short exposures.

- **Bounce it:** Built-in flash is not ideal for interiors, lighting up nearby objects but not more distant. If your camera allows, use an external flash with bounce flash instead – you'll get more consistent results.
- **Make use of ambient lighting:** Don't be afraid of turning on the artificial lighting in a room. It will increase the light levels and can sometimes balance sunlight or exterior lighting.
- **Set the white balance:** You'll be fine using the auto setting most of the time, but for accurate results if there is artificial lighting available, switch accordingly.

Interiors: balancing interior lighting with exterior can be problematic but most cameras make a great job of it when set to auto

TIP

Estate agents and realtors are in the business of making the interiors of even the most modest of properties look saleable. Go online and look at the way they represent properties. They tend to make good use of wide-angle lenses (which make rooms appear larger) and effective lighting.

Tableau: this museum tableau was captured by setting a modest underexposure to preserve the light effects of the original scene. Flash would have ruined the atmosphere here

CLEVER IDEA 42:
A DIFFERENT ANGLE

Inevitably, most of the photos we shoot are from eye level, square on to the subject. Varying this stance – and angle – can produce some really powerful shots.

When you're visiting a tourist attraction, take a look around you. Just about everyone is shooting pretty conventionally: standing upright, with the camera held to his or her eye. There is nothing wrong with this; it's a great way to get shots quickly and it's also practical as you can generally hold the camera firmly and still in this position. Vary this position, however, and you can get some fantastic shots.

LOOKING DOWN

Pointing your camera down from a higher position provides that superior view: you, via the camera, are looking down on everyone else. Use your camera held high to shoot over the heads of crowds – and if your camera has a fold-out screen, you can compose and frame your shots even when shooting at arms length.

LOOKING UP

If you want to give your subjects a sense of power or dominance, go for the low camera angle by crouching low and angling the camera upwards. People shot from this angle appear more forceful and influential. Buildings and even plants shot from below also seem more imposing than, say, a building shot from a distance or a plant shot from above.

Look down: fold-out viewing screens are ideal for getting both over-the-head type shots and downward angled views

> ### (I) SHOOTING CHILDREN
>
> Children are best shot at their eye level, or even from below their eye level, with the camera looking up at them. Shooting from a position above their head can make them appear inferior and subordinate, something that's unlikely to be your intention.

Roman temple: this building did not have much impact when shot square on. Getting in close and aiming the camera upwards created a more powerful result

DIAGONAL COMPOSITIONS

Conventional photography rules dictate that you should always ensure you hold the camera precisely level. This is all well and good for the greater number of your shots, but sometimes turning the camera to an extreme angle – so that key horizontal or vertical lines cross the frame diagonally – can deliver some potent results.

Shooting tall buildings is a case in point. You're standing in front of a tall building and your camera lens doesn't quite allow you to fit the whole building in the shot, from ground level to topmost point. By turning the camera to fit the building into the shot on a diagonal line will often provide you with that extra bit of headroom to accommodate the extra height.

However, don't limit yourself to using this technique on tall buildings alone. Diagonal lines in compositions generally work much better than horizontals and verticals, particularly when trying to add depth to your photos.

Campanile: the cramped environment of St Marks Square, Venice, makes it hard to get a good, straight image of the Campanile. Rather than shooting a truncated view, shoot diagonally to create a powerful composition; the fact that you can't see the base of the tower is almost immaterial

Composing with diagonals: keep the key subjects flowing along the diagonal line to help create stronger, more graphic images.

CONVERGING VERTICALS

Shooting diagonal compositions for tall buildings can also help the problem of converging verticals. It's a big name for a simple problem: when you point a camera upwards, all the vertical lines, that should be parallel, seem to converge at a distant point. We take this for granted when we look at subjects like this with our eyes but the camera, which is utterly unforgiving, reproduces the distortions faithfully. And although faithful, the distortions can make your shots look odd. Using a diagonal composition actually accentuates this but does so by similarly accentuating height – it looks to everyone viewing the photo that you meant to do it.

Converging verticals: the straight shot of this modest building shows the problem with converging verticals; the building appears to narrow towards the top. Turning the camera so that the building's axis lies along a diagonal doesn't diminish this effect, but turns it to advantage, emphasizing height instead.

CLEVER IDEA 43:
THIS CAMERA BELONGS TO...

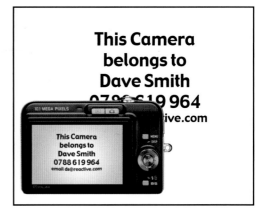

Losing a camera or a camera phone when you're out and about can be devastating. And once lost, many of us presume the item is gone for good. Actually many are never re-united with their owners because they can't be paired up – there's no easy way to link the device to its owner. But here's a way to make that process so much simpler.

Take a photo – the first on the camera or phone – of a card on which you've written your name and contact details. Anyone who finds your camera will usually first look for evidence of identity by viewing the images. The first one they'll see will show your details and, hopefully, a reunion will only be a question of time.

Home screen: shoot an image of your name and contact details to help the process of reuniting you and your lost kit

TIP

For security reasons, don't use your home address as contact details. Instead use a work address or put mobile phone and email contact details only. Should the device fall into less-than-honest hands, this means there will be no identity theft issues.

CLEVER IDEA 44:
LOST LUGGAGE? NO PROBLEM!

Losing luggage in transit whilst travelling can be a major problem, but how about making finding it much simpler and less stressful?

Before you travel take a photo of your entire luggage, including in the shot something to give a sense of scale – a ruler, for example. Now, if the worst happens and one of those bags goes astray, you can show the staff on the lost luggage counter actual pictures of what has been lost. No need for those vague hand-waving descriptions or approximations. Of course, make sure you carry your camera in your hand luggage; don't pack it in the luggage that might potentially go astray.

Comparative size: include something in your shot that conveys the size of the item

A COPY OF TRAVEL DOCUMENTS

Why not keep copies on your camera or camera phone of all your travel documents, too? A page from a passport or a photo of your tickets may not be legal documents, but these images can help immensely if you lose the corresponding originals as they contain crucial information and data.

Don't forget that some tickets and boarding passes are now issued in electronic form and can be stored as a camera or phone image. These can be scanned from your device as you pass through ticket barriers or check-ins so you don't need to provide a paper copy. You just need to ensure that your phone doesn't run out of power.

CLEVER IDEA 45:
RESOLVE HOLIDAY DISPUTES

Let's be honest, most holiday destinations are great and offer us a fantastic break from everyday life. But now and again things can go wrong. We've all heard of, or maybe seen on TV, holidays from hell. Breaks that should have been a trip of a lifetime that descend into something more stressful and unpleasant than anything that could befall us at home. Thankfully the reason that these make the headlines is because they are exceptionally rare. For every horror story, there are a hundred, a thousand, and probably more, holidays that are absolutely fantastic.

If things aren't as you had expected, keep your camera to hand and make sure you record the details. It's so much easier – and puts you in a stronger bargaining position – if you have documentary evidence when you return home. Photos of mould or bad plumbing won't get pride of place in your family photo album, but they really could help you reach an equitable solution with a holiday company.

Holidays: fortunately most of us have nothing but great memories from our holidays – but keep your camera at hand in case your holiday home doesn't match the brochure description

PERSONAL SECURITY

When travelling, take a shot of a taxi and its number plate if you're in a dubious location – then email the photo to a loved one before setting off. Don't be paranoid, but always put safety first.

Taxis: before climbing in, take a shot of the number and/or license plate and email it home

CLEVER IDEA 46:
LOCATE YOUR CAR

It's often such a relief finding a parking space in car parks at busy venues or airports that we often lock the car and head off, without a second thought for where we have actually parked. Then, when the time comes to return, we are literally at a loss as to the car's location. Of course, centre and venue managers try to make things easier by branding car parks with names, number, and colour schemes, but even if you do remember some of these details it may not be enough to locate your vehicle. And after you've been away on holiday for a couple of weeks, memories of the parking location can be even more distant.

An ocean of cars: a day spent at a show or on a week's holiday can erase any memory of your parking place, and the search for its location can prove long and stressful

Taking a couple of shots of the location of your car, including some landmarks – and car park signage – can dramatically help you find your car faster in those endless car parks. This idea is particularly useful if you are parking somewhere strange and unfamiliar or are parking at a major event, where parking may stretch across several seemingly identical fields. If nothing else, it gets you into the habit of making a more effective note of your car's location!

CLEVER IDEA 47:
WHO'S THAT NEXT TO YOU?

Today's car parks seem to dedicate less and less space to each parking bay. Or is it that cars are getting larger and larger? Whatever the reason the chances of getting a ding or dent from adjacent door openings, or getting a wing mirror clipped from a manoeuvring vehicle, are always increasing. And the chances of someone who causes damage owning up to it are, sadly, on the decline.

So when you're shooting your car's location in a car park, include a shot of your neighbour's, too. Of course this is not a foolproof method to identify anyone that might have caused damage, but it could be the first step to tracing the culprit.

Shoot the neighbours: when you're parked, take a shot of the neighbouring cars to help identify any miscreants

RESOLVING PARKING DISPUTES

Taking a shot of your car and where you've parked it can also be useful in resolving parking disputes. Disputes over parking where signs are ambiguous, or where actual parking positions are disputed between you and an official, have – on many occasions – been resolved quickly and painlessly by the provision of a photo.

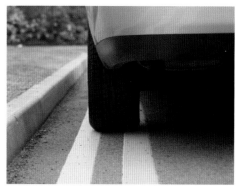

Parking restrictions: a photo can quickly confirm your innocence – or guilt – and avoid costly disputes

CLEVER IDEA 48:
RECORD RENTAL CAR DETAILS

When you're picking up a rental car at the airport after a long flight, there's a tendency amongst many travellers to be a bit blasé about the vehicle check. A cursory examination often misses crucial dents and marks for which you could be later charged.

Next time you walk around a rental car with the company clerk, take your camera and take some shots. Even if there's nothing obvious in the way of damage, some photo evidence could prevent lengthy – and costly – disputes down the line.

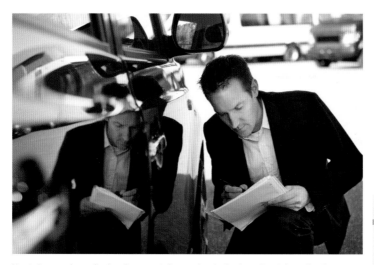

Rental car: when signing for a rental car, check the log sheet that details any actual damage carefully, and take a photo of any damage you can see

> ### TIP
>
> To avoid any disputes or ambiguity, shoot the pictures at the rental location, and feature the vehicle licence plate. Make sure you shoot any marks or dents in close up, too.

CLEVER IDEA 49:
USE YOUR SMARTPHONE AS A PHOTO ACCESSORY

If you're one of those people that doesn't use the camera on your smartphone that much – perhaps you carry a camera anyway or are more used to using the gadget as a phone (yes, really!) – that smartphone can still be a very useful photo accessory.

There can hardly be more praise for a camera than to have a leading photographer endorse it; and you'd struggle to find a pro using, let alone recommending, a camera phone. So it was something of a revelation when the lauded US photographer, Annie Leibovitz, declared the iPhone 4S smartphone as a great point-and-shoot camera. Apparently she then went on to shoot a picture of her thumb. How many of us have also done that?

A smartphone – or camera phone, whatever you prefer to call it – remains for many of us a device we carry in addition to a conventional digital camera. Some people, it seems, prefer to leave a phone handling phone calls and a camera taking photos. But even if you do (perhaps unfairly) ignore the camera element of your smartphone, there's still plenty that the phone can do to make your photography better and more effective.

How? Well, just think of what that phone can do for you when you're out shooting. Here are just a few functions that a phone can provide to help you get those great shots.

POCKET WEATHER STATION

Weather apps let you know the weather conditions recorded at the nearest weather station to your current location, or at your destination. They can offer useful information before you commit to heading off on that mountain trek. You can even use weather apps to assess your chances of getting some good shots of sunrises or sunsets.

WHERE AM I?

GPS and/or built-in map features help you to navigate your way to those great sights. Some will even point out great photo opportunity points. The clever thing about maps on smartphones is that they always know where you are, so act pretty much like satellite navigation systems. There's no chance of you mistakenly reading a wrong location and heading off in the wrong direction. A smartphone map application is also a lot more compact – and up to date – than your typical printed one.

Maps on your phone: pinpoint your position with a GPS-linked map application

Weather apps: common to many smartphones, weather apps provide accurate local weather forecasts for both the present and the future

Take it with you: a back up of important information such as destination maps is always a good idea when travelling widely

A LIBRARY SHELF OF GUIDEBOOKS

Particularly if you are travelling by air, taking a good selection of printed guidebooks can be a problem, as they'll eat too heavily into your baggage allowance. On your smartphone you can pack a dozen or so books easily. And referencing them is often easier than referencing printed books as you make your way around unknown cities.

POCKET COMPASS

Don't pack a separate compass when travelling; just download a compass app for your phone. It's a useful add-on to a map app.

TIP

You can also use your smartphone as a pocket notebook to record audio and/or written notes as you travel.

Compass: compass apps such as this often come preloaded on smart phones or are freely available for download

SMART APP FOR SMARTPHONES

Applications like The Photographer's Ephemeris (TPE) are ideal for the landscape photographer. Combined with a free weather app and going several steps better than a simple compass, TPE can give you instant feedback on the position of the sun and moon in your photos so you can get that perfect lighting, or avoid deleterious shadows. Available for iOS and Android.

MEDICAL HELP

If you're stuck in a wilderness that boasts mobile communications, you can send photos of injuries or medical problems to your doctor for diagnosis. Just don't let this excuse you from calling for emergency help where necessary. Also try keeping a photocopy of any medical prescriptions you might need, just in case you need to get one fulfilled when away from home.

NO SIGNAL?

Of course, many of the 'live' features a smartphone offers are conditional on you receiving a mobile signal. When that goes you could be left, in many senses, high and dry. And it's not just remote regions that have no signal; there are plenty of holes in the coverage much closer to home.

Take precautions by backing up important data and information before you leave home, or at least before you leave a strong signal. For example, take screenshots of online maps or even photograph printed maps relating to the regions you're visiting. It's also worth checking coverage in advance; you may be able to swap your phone's SIM card prior to travelling to one from a network that offers better coverage at your destination.

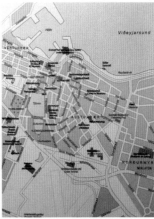

Guide books: hyperlinked guides are a convenient way to carry large amounts of information around with you. And the small screen is not as inconvenient as it might first appear

CLEVER IDEA 50:
USE YOUR CAMERA WITH DISCRETION

It's easy, particularly when travelling overseas, to get carried away photographing anything and everything. It may be a once in a lifetime opportunity. But how can you be sure you're safe and, in particular, not shooting your way into serious trouble? Go to any event or any tourist location and you can be sure a fair number of the people around you will be sporting cameras or camera phones. It sometimes seems that dystopian fears of our every move being photographed are coming true, albeit by a benign army of which we may well be a part. Although it seems everything and everyone is under continual scrutiny, there are some occasions when you'd be well advised to keep your camera out of sight. Let's take a look at some.

SAFETY FIRST

Sadly, some of the most romantic and picturesque corners of our world – even if they are just around the corner – are not the kind of places where you'd necessarily want to sport cameras as they are a magnet location for theft. The rule here is discretion; invest in a camera bag that's discrete or ambiguous, the type that might be carrying nothing more valuable than a packed lunch.

CULTURAL SENSITIVITIES

Despite the tendency of the world to become increasingly culturally homogenous, many cultures still have their own specific sensitivities when it comes to photography. Check tourist guides, websites and even hotel staff to avoid faux pas. You don't want to inflict grief on yourself or others, or cause offense to the local people, even if unintentionally.

Sensitivities: always be mindful of religious or cultural sensitivities before grabbing a shot

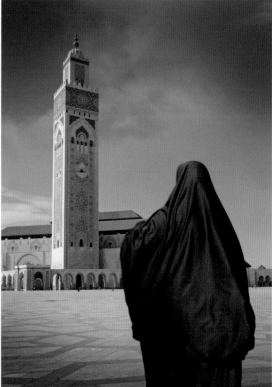

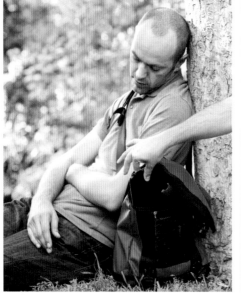

Keep it safe: it's almost stating the obvious, but when carrying valuable kit – such as cameras and phones – it's essential to keep them safe at all times

HISTORIC BUILDINGS AND MUSEUMS

In some you can take photos; in others you can't. And the reasons when you can't are various: 'The damaging cumulative effect of flashguns'; 'Security'. It has even been said that some museums discourage photography to help improve sales of catalogues, guides and postcards from the gift shop. Whatever the reason, take note of any restrictions on your way in – or your visit may turn out to be a great deal shorter than you had planned.

PLACES OF WORSHIP

Sacred sites often limit photography. It may be for religious reasons; it may be for the benefit of others who are affected by the noise and flashlight from cameras.

No photography: no matter what language it may be in, 'no photography' and 'keep out' signs should be obeyed

WHEN ASKED

Often someone with an SLR camera and tripod will get stopped, whereas another person armed with a compact camera will not. A discrete compact can imply 'tourist' rather than pro, and will probably not attract attention. Whatever you use, if you're on private property and asked not to take photos, it's good form to follow the request.

ASKING PERMISSION

Here's a tricky one: should you ask permission to take photos? Politeness says 'yes'; seasoned photographers would say 'no'. The reason for the latter is that if you ask and get the answer 'no' you've painted yourself into a corner. If you don't ask, shoot away and then get asked not to, at least you've a few shots in the bag, or the camera. It's something of a moral dilemma and one that I'll skirt by, leaving to your own conscience.

NATIONAL SECURITY

Shooting photos from the perimeter fence of military airfields in any country will likely attract unwelcome attention. In some countries civil airports (aviation enthusiasts beware) and even bridges are regarded to be of strategic importance and photography of them is therefore banned. Ensure you are fully aware of restrictions imposed by threats to national security and follow them rigorously.

BEING REALLY CANDID

Here's a trick I've seen done by many a photographer to get some candid shots without the hassle of having to ask. Appear to be viewing and shooting a building but, at the last moment, drop the camera to shoot interesting people in the foreground instead. Again, this is an idea not to be used where there's any risk or contention, but it's great to capture those really natural shots.

CLEVER IDEA 51:
LIGHT UP THE DARK

Let's face it, a torch or flashlight is rarely top of the packing list for an average holiday. But when you need something to light your way during your travels, what can you do? Here's a clever little way to turn your camera into a light source, sufficient to light a dark corridor or even navigate your way around a hotel room to find the light switch. You'd be surprised at the light output from even a modest camera.

By 'light source' of course, we're talking about the LCD panel on the back of a camera, or the main display of a camera phone. We'll ignore here those accessory devices for phones that are actual flashlights and attach to the device – you're just as likely to forget to pack one of those as you are a regular flashlight.

TURNING AN LCD PANEL INTO A LIGHT

Doing this is surprisingly simple. Shoot a photo (either before you go away, or at any point on your trip) of a white piece of paper. Don't worry about it being in focus, and if your camera allows it, set it to overexpose. Then, when you next need a light, set your camera or camera phone to display your photos and select the shot of the white paper. Job done! Do treat this as an emergency light source only, as it's not going to last all night. And do remember to recharge the battery of your device afterwards, or your camera will be good for nothing the next day.

A light in the dark: don't underestimate the light you can generate from a humble camera or camera phone

ⓘ FLASHLIGHT APPS

There are actually a number of Android and iOS applications that can turn your phone instantly into a flashlight. Just search the respective app stores for Flashlight.

Flashlight app: the simple way to turn your camera phone into a light

A REAL LIFESAVER

Can you think of any circumstance where your camera or camera phone could save lives? As a means of contacting emergency services, your phone is naturally well placed. But what else? Well, using one as a flashlight. I'm sure this case is by no means unique, but as I was writing this I heard a story of a group of people in the West of England who were cut off by rising tide on a dangerous beach. Too far to call for help and without a mobile phone signal, they used their cameras and camera phones to generate crude Morse-code signals. Those signals were seen and the party was successfully rescued.

CLEVER IDEA 52:
FIND YOUR WAY HOME

Some cities are easy to navigate: systematically named roads (as in US cities), or principal thoroughfares and boulevards, as in European cities, mean it's relatively easy to track your way. But what about when you head off into seemingly endless suburbs? Or explore North African kasbahs? Not so easy then.

Or, without a camera it wouldn't be. Try shooting a photo trail – at corners and landmarks – to make it easy to retrace your steps. In fact, there's no reason why you shouldn't use the opportunity to take great photos – rather than just simple locational shots – each time. Then you can turn your exploration into a city trail, as described below.

CREATE A CITY TRAIL

Help friends – or indeed anyone – discover more about a city, town or village by creating a simple photo trail. Most cities today have tourist trails – you've probably seen the little plaques on the ground that indicate where you are along with a link to a leaflet or guidebook. It's easy to create your own photo version, however small your town.

Start by planning – informally – a route that incorporates interesting sites that enthusiastic visitors would like to see. Then head off with your camera and shoot them. Take shots of small details and curios too; all these things help visitors get a good, full view of the city.

City trails: help people discover more about your home or favourite city location by compiling a photo trail to record it

CLEVER IDEA 53:
USE YOUR CAMERA AS AN IMPROMPTU MIRROR

Here's one of those ideas that sounds crazy but just works – when you need it most. Use your camera as an impromptu mirror! It's perfect when you're out and about with an urgent need for, but no access to, a real mirror.

Use your camera to shoot a self-portrait and then examine the image on the viewing screen. It's perfect for spotting smudged make up, checking blemishes, and so on.

If you've a camera phone with a front facing camera you can go one better and work on a live, real-time image. Just activate that front facing camera and you're all set.

CLEVER IDEA 54:
USE YOUR CAMERA AS BINOCULARS

Save yourself the hassle of taking – and the cost of purchasing – binoculars by exploiting your camera's zoom lens. There's no doubt that many cameras today sport pretty formidable zoom lenses, ones that can really get you into the thick of the action. But did you think about using this zoom as a surrogate pair of binoculars? OK, so with just one lens we should technically be talking about a spotting scope rather than binocular, but the idea is just the same.

Most cameras can emulate the zoom ratio of many binoculars and scopes, and some can achieve the most powerful magnifications. By using your camera as a magnification device, you have the added bonus of being able to shoot a photo of the magnified scene as a record. And, once you've shot the image, you can even examine it more closely: display it on the LCD screen and then simply enlarge. This gets you in really close!

 FOCAL LENGTHS

Here's an example of how increasing the zoom ratio can get you in close. The normal camera lens view is (very) roughly equivalent to the 50mm setting. So the 100mm setting on the lens is equivalent to a 2x magnification, and 300mm will be a 6x magnification.

If we wish to be pedantic, I'd have to note that in general the focal lengths quoted are '35mm equivalents'. That is, the equivalent to that on a 35mm camera. This is mainly for historical reasons now, but does provide us with a direct comparison of lenses across all types of cameras.

What you see: here's what you would see through the viewfinder or on the camera's LCD panel at 28mm, 50mm, 100mm and 200mm settings

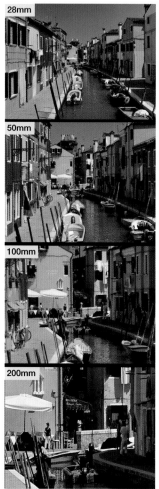

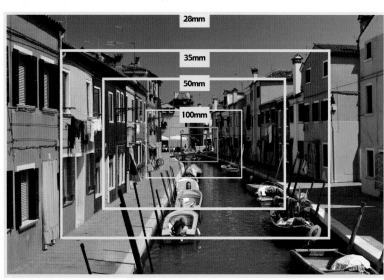

Getting in close: here's how you can get in close with a 10x zoom lens. The orange frame corresponds to a focal length of 200mm and the red to 300mm

Ⓘ SHOOTING PHOTOS WITH BINOCULARS?

If you can use a camera as binoculars, could you use binoculars as a camera? There are adaptors that allow you to attach a camera to a binocular or spotting scope lens, but there are also binoculars with built-in cameras. Some of these are at the gimmicky end of the market (for which read 'of questionable optical quality as binocular or camera') but there are some potent pro offerings, such as this VistaPix model from astro-scope specialists Celestron.

VistaPix binocular camera: part of a range from Celestron, this binocular camera combines first rate optics in the binocular with a matched camera, letting you photograph exactly what you view

NOT IN THE THEATRE!

You could also use your camera as opera glasses – but it's not recommended. Not for reasons of quality but because copyright laws generally forbid the use of cameras in theatres and cinemas. You could argue you were only trying to get a good view, but I fear that argument would fall on deaf ears.

CLEVER IDEA 55:
USE YOUR CAMERA AS A MICROSCOPE

If you need to read the really small print anywhere and don't have a magnifying lens to hand, let your camera come to your rescue. Switch the camera to macro mode and scan the text. Depending on how close you can get you'll be able to read it clearly on the camera's LCD screen. Or take a photo and then replay it, zooming in if you need to get even closer.

Small print: have you ever tried to read the really small serial numbers on small electronic devices, such as an iPod nano, unaided? Fortunately, for those not blessed with the sharpest of eyesight, your camera can come to your aid

UP PERISCOPE!

Microscope, binoculars – we've discussed how your camera can act as either already, but what about a camera as a periscope? You can hold it over your head to shoot above a crowd or even over a tall fence. Or get a shot of what's on top of that cupboard without having to resort to a precarious climb.

Over the top: whether it's getting a better view or something more salacious, your camera can make a great periscope

CLEVER IDEA 56:
CREATE A VISUAL GIFT LIST

Here's an idea that probably requires that you gain access to your friends' and family members' cameras or camera phones. It might be coming up to Christmas or your birthday, or you may just want to drop a hint. How many times have you given someone a list of potential presents, only to find the list is either misinterpreted or misunderstood? It's estimated that each year billions are spent on presents that remain boxed or wrapped, never to see the light of day again.

Cut down the risk of this happening to you by shooting your wish list using the camera of the respective purchaser. With a quick reconnaissance of a shopping district you can quickly grab shots of preferred items in store windows or even inside the stores. You can include the store names in the photos and even the price labels. Once you've returned the camera or camera phone to it's rightful owner they'll be presented with a very obvious list of items from which they can – at their leisure – choose and purchase the appropriate gifts.

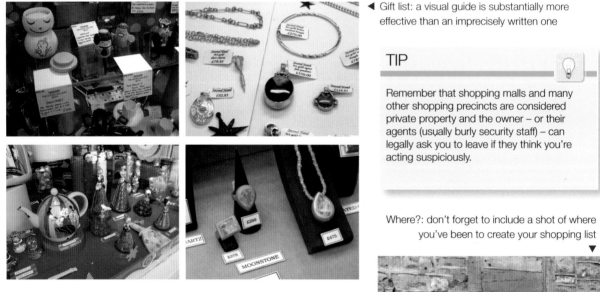

◀ Gift list: a visual guide is substantially more effective than an imprecisely written one

TIP

Remember that shopping malls and many other shopping precincts are considered private property and the owner – or their agents (usually burly security staff) – can legally ask you to leave if they think you're acting suspiciously.

Where?: don't forget to include a shot of where you've been to create your shopping list
▼

AVOIDING TROUBLE

Despite the proliferation of cameras and camera phones and the casual way they are used at every opportunity, you may still find that some stores aren't too keen on letting you shoot their products. There's a real concern that your motives may not be honourable. At best, they may think you're comparing their products with other stores; at worst, they may think you're checking out the store for a future theft. Usually a brief explanation should assuage any worries on the part of the retailer.

CLEVER IDEA 57:
MAXING THE SHOPPING EXPEDITION

Online shopping and shopping tools have made it easy to compare the same – or similar – products across a wide range of e-tailers. When we work the high street or shopping mall doing much the same we normally have to rely on memory. How many times have you thought 'Now, where did I see that?'

Taking a shot of the product – and perhaps the price label, too – makes it easy to compare multiple items or even compile a wish list. Photos don't have to be arty, a simple snapshot will do. And turning off the camera's flash is a good idea to avoid any undue attention from store staff.

Labels: a quick shot of the label helps confirm product information details and makes later comparisons easier

GET A SECOND OPINION

If you're undecided whether something looks good on you, why not use your camera phone in the changing room to take a shot that you can review or even send to a friend for an objective opinion? This could help you avoid a costly mistake.

EVEN SMARTER SHOPPING

As well as recording items for future reference, owners of smart phones can go one better. You can download apps that let you read and interpret the barcodes on selected items. So, rather than just getting the price-tag info, you can scan the code, then obtain – and save – all the product information, too. Depending on the code, you can find out details such as pack sizes, country of origin, and more.

Also look out for QR codes, now featured in many stores as well as in online and printed advertising. These super-barcodes that look like a pattern of random spots, give you access to even more store and product information. You'll need a special – and generally freely available – app on your phone to read these codes.

Scan that barcode: barcode reading apps make it easy to scan and record barcode information

QR codes: scan QR codes to get enhanced product information when you're on the go

CHAPTER 3:
EXTENDING AND ENHANCING YOUR CAMERA SKILLS

This chapter is all about pushing your camera skills that little bit further. We'll be looking at how you can shoot when conditions get a bit extreme – and the relatively simple precautions to take to ensure your camera survives the experience. And did you know your camera probably includes some cunning features that will let you shoot brilliant photos across a wide range of situations? Mastering them is easy and you'll soon be shooting like a pro. Except without the years of study and practice.

We will also take a look at how we can move beyond shooting what we might call 'normal' photos. For example, we'll explore how simple it can be to create breathtaking panoramas, and even three-dimensional photos. And what about movies? Just about every digital camera today has a movie mode that can record short clips of

movie footage, but what if your movie ambitions are a bit more ambitious or you want to be a bit more creative? We'll suggest a couple of ingenious ideas that will enhance your abilities in the movie-making arena.

We'll conclude by taking a look at how we can protect our investment, as this is a vital part of camera know-how. A digital camera makes it simple to shoot a large number of photos, and your collection will become part of your treasured memories in years to come. They could even become a valued asset for future generations. So we'll discover how we can guarantee those images will still be there for future generations to enjoy and, somewhat speculatively, how we can shoot photos today that could be improved upon in years to come.

CLEVER IDEA 58:
SHOOT IN AND AROUND WATER

Some of the best photo opportunities occur in or around water. Think about it – beaches, rivers, lakes, even aquatic locations during thunderstorms – these all make great subjects. However cameras and water don't generally mix. So how do you exploit the opportunities without risking your valuable kit?

Some cameras claim to be splashproof, sufficient for a modest dousing of rain, while others stress their waterproof capabilities. If your camera isn't touted as being either, you don't know, or you just don't want to tempt fate, how can you flex your aquatic ambitions in safety? Here are a couple of ideas:

TIP

Waterproof bags can provide a great seal against sand and dust.

OPTION 1: BUY A WATERPROOF BAG

There's quite a market for waterproof bags that can fit a camera, a mobile phone and any other valuables you want to keep dry. Made of tough, flexible plastics with a clear panel or window allowing you to shoot through, these bags also have a large opening through which the camera can be passed and then sealed. They are lightweight, easy to pack and waterproof to a depth of 3m (10ft) or more. They are absolutely ideal if you want a keenly priced solution and only plan on getting wet rarely.

WATERPROOF BAGS

Likes: Low cost, small size, light weight and effective

Dislikes: Not suitable for use in deep water (high water pressure will cause leaks). Some camera controls can be difficult to use because they are hard to reach in the bag

Waterproof bags: like this one from Aquapac, are inexpensive yet effective

OPTION 2: INVEST IN AN UNDERWATER HOUSING

If your underwater ambitions are a bit more serious, take a look at underwater housing. Rigid and precisely engineered for specific camera models, these fit snugly around the camera and provide the ultimate in protection and waterproofing. They do come at a cost – often as much as the camera itself – but let you operate the camera easily and fully, even in deep water. And if you're a diver you'll also be able to operate the camera controls with gloved hands.

UNDERWATER HOUSING

Likes: Suitable for deep water, easy to use all the camera controls, robust

Dislikes: High price, and they are custom-made for specific camera models so if you get a new camera you'll need a new housing

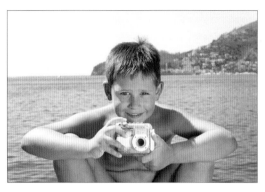

Underwater housings: these are robust and let you operate all the camera's controls easily

 SPLASHPROOF VS WATERPROOF

Many cameras are sold as splashproof, but what does splashproof actually mean? Take it as meaning you needn't panic if it gets lightly splashed, as might happen at the poolside or under a light shower of rain.

On the other hand, waterproof cameras can survive a dip in the sea or a hammering from heavy rain. In fact they'll be safe in deeper water – 3m (10ft), 10m (33ft), or even more in some cases.

Whether waterproof or splashproof, do follow the instructions that came with your camera, especially regarding seawater. Salty water can still cause damage to your gear if those instructions are not followed.

SERIOUS UNDERWATER CAMERAS

Diving enthusiasts and those who take underwater photography seriously choose specialist underwater cameras. Many are really expensive – representing their specialized nature – but there are some more economically priced models. Check out SeaLife cameras; think of these as cameras with their own built-in waterproof housing. Compact, but easy to use even with gloved hands and in the extreme conditions found underwater.

SeaLife cameras: a great solution for the serious underwater photographer, without going all the way to full pro kit

CLEVER IDEA 59:
CAPTURE SWEEPING PANORAMAS

There's something completely compelling about broad, sweeping panoramas. Photographers – like artists before them – have been inspired to shoot them. So why not shoot one yourself? Capturing a great panoramic shot involves shooting several photos of your panoramic scene and then joining these seamlessly together. So it's normally a two-stage process: first gathering the photos, and then joining them together to produce the completed panorama. However, some cameras make this process a great deal easier by featuring a specific panoramic mode.

PANORAMIC MODE

Some cameras make the job of shooting panoramas very easy. They have a panoramic mode that, when selected, allows you to take the individual shots that will comprise the panorama sequentially – as you progress, the mode automatically builds your shots into one panorama. Once you've taken all your shots, your panorama will be assembled in-camera and saved, ready for you to enjoy.

DIY PANORAMAS

If your camera doesn't have this shortcut don't worry, any camera can be used to gather the component images – you then just need to assemble them later using photo-editing software. Here's how:

1. Set the camera's zoom lens to a standard or moderate telephoto focal length and take your first shot.
2. Move the camera to the right (if shooting left to right) to take the next shot. Overlap the previous one horizontally by about one-third; this aids the software when it comes to build your panorama.
3. If you can, use a tripod to ensure that consecutive shots are perfectly aligned. If shooting by hand try to keep the camera as level as possible.

Download your photos to your computer and let the software create your panorama. Most photo-editing applications have a panorama generator; in software such as Photoshop, or Photoshop Elements, it's a feature called Photomerge. The result, after a few minutes' processing, is a seamless panorama.

Stitched panorama: produced using image editing software, these four images have been melded into a single seamless panorama

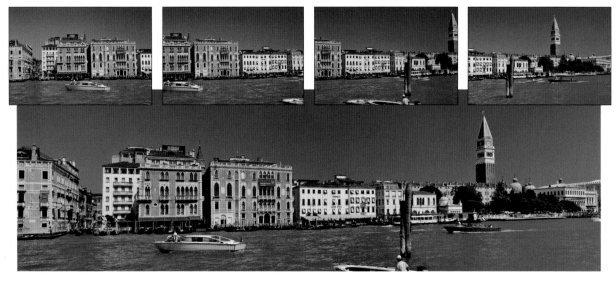

AVOID THE ONE-SHOT PANORAMA

Avoid the urge to create panoramic shots by simply shooting with your camera's zoom lens set to its widest setting. You'll find you end up with an image where most of the frame is wasted on superfluous sky and foreground. And the strip of landscape in the middle will be so poorly defined it won't impress anyone.

SWEPT AND 3D PANORAMAS

Some cameras can let you shoot a panorama in real time: you just sweep the camera across the panoramic view with the shutter depressed, then release the shutter button to save your panorama. Some Sony models even allow you to record in 3D!

CLEVER IDEA 60:
CREATE VERTICAL PANORAMAS

Photos can be stitched together vertically as well as horizontally; this is a great way for capturing those tall buildings or scenes that you couldn't accommodate in a single shot. Taking this a step further: in confined spaces you can use a process known as 'quilting' to take shots horizontally and vertically, thereby producing a photo quilt.

St Andrews Cathedral: space is at a premium here so this shot was compiled by quilting nine images together

(I) GOOGLE STREET VIEW

Arguably the greatest example of panoramic photography is Google Street View; in many countries there's hardly a road now that you can't explore thanks to this comprehensive collection of panoramas. To compile this impressive collection Google use a custom-made camera and recording system. Multiple lenses record 360 degrees at, above and below eye level. Photos are taken on the move, recording repeatedly as one of their vehicles drives around.

SHOOT A PHOTOSYNTH

If you have an iPhone (or some other devices) you can shoot Photosynths. These types of panoramas can be truly immersive as not only can you shoot wide views, you can also shoot up, down or all around. The camera on the phone automatically shoots images as needed to build up the total image in any format.

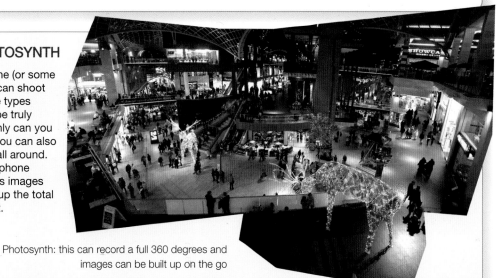

Photosynth: this can record a full 360 degrees and images can be built up on the go

CLEVER IDEA 61:
BECOME A SHARPER SHOOTER

Blurred photos are the bane of many a photographer. Your classic shot in every respect – apart from its sharpness. Why do we end up with blurred photos? It can be (perhaps obviously) down to not holding the camera steady: either moving the whole camera when taking a shot, or pressing the shutter release too forcibly. Or it could be down to the subject itself moving. Here we'll explore some clever ways to ensure you achieve sharp photos every time.

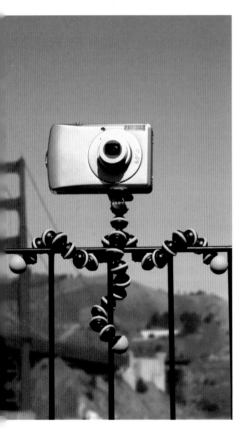

MOVING SUBJECTS

There are many great opportunities that involve moving subjects. For example, children playing and dancing, people taking part in action sports, and more. To make sure you capture the action and get a pin-sharp photo, you need to select a shutter speed on your camera that is very short.

On many cameras you may not be able to do this directly, in which case you can select the action or sport scene modes instead. These mode settings will configure your camera to deliver the best results for fast moving subjects.

When the light is a little dim your camera may struggle to set a fast shutter speed. In this case, you need to pan the camera. Follow the action by turning the camera to keep that action at the same point in the viewfinder or on the LCD screen, then gently press the shutter.

USING MOVEMENT

Sometimes you may not want to freeze movement – instead you want to emphasize the speed or dynamics of the subject. In this case you need to select a slightly longer shutter speed and ensure that, if you want to keep the subject in focus, you follow that subject or, if you want the background sharp, you keep the camera still.

TIP

Digital photography lets you shoot away with impunity. In action or sports photography, positions and expressions can change in an instant and, despite your best efforts, the odd shot can still turn out un-sharp. Hedge your bets by shooting away mercilessly.

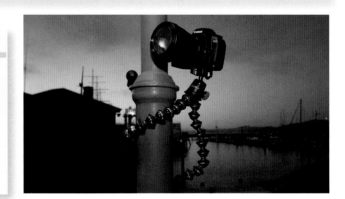

SUPPORTING YOUR CAMERA

In a crowd of camera users, professionals can often be picked out because they are the ones sporting, if not always using, tripods. So, should you follow their example? If you want sharp shots the short answer would be 'yes', but this is not always practical. However, you can still take measures to make sure you always get sharp shots.

Get a firm hold

Here's the simplest solution, although it's not suitable for all occasions – hold the camera steady. Get a good grip on your camera, holding it firmly, rather than daintily. Then, when you want to take a shot, gently squeeze the shutter.

Mini tripods and supports

Some cameras come complete with a mini tripod. Just a few centimetres tall and with limited adjustments they are cheap (if you need to buy one) and easily pocketable. They are sufficient for compact cameras and some mirrorless SLRs, but are rarely up to the job of supporting a larger camera.

More flexible – in every sense – are Gorillapods. These are ostensibly tripods, but the legs are made from cunning ball-and-sockets that allow you to flex them in almost any way. So you can use the pod conventionally as a tripod, or wrap it around a post, brace it against a wall, or clamp it on to any support. Gorillapods come in a range of sizes and strengths that make them ideal to use with everything from a camera phone through to a digital SLR.

Clamps

Once a popular pocketable accessory, a clamp mount lets you clamp the camera to fence posts, chair backs and, well, frankly anywhere you can attach a clamp. To be honest, they are not that adaptable to use and can leave marks with their pincers.

Impromptu supports

Most of the time you probably won't be carrying any form of support with you. So how can you ensure that your photos will be sharp? Bright light will ensure you are able to use short exposure times – always a boon to vibration control – but otherwise make use of impromptu supports. Rest your camera on a wall or hold it against a post. A few coins or a wallet placed underneath can help get the camera level, too.

▲
Gorillapods: in a range of sizes that can be coaxed into just about any position these are the last word in versatility

◄ Minipods: basic but sufficient for the smallest cameras

▲ Walking pole: here's a great solution – a walking stick with a camera mount built into the handle. And it folds away when you don't need it. Not as robust as a tripod, but fine for all but the longest exposures

MAKE YOUR OWN SUPPORT

Here's an easy solution to keeping your camera steady. Go to a department store and buy a wheat bag – you know the sort of thing, a bag filled with wheat that's designed to be heated up in a microwave. Go for the non-fragrant ones, if you want to avoid your camera kit bag – or pockets – smelling of lavender. You can scrunch this up and get it to support your camera at virtually any angle on any surface. And if you're on a long journey you can still use it for it's original purpose.

CLEVER IDEA 62:
ORGANIZE A PHOTO TREASURE HUNT

A photo treasure or scavenger hunt is all about getting you, as well as others, to put your camera or camera phone through its paces and stretch your skills. You probably know the score with a treasure hunt. You're given a set of items that you have to collect either in a given time or along a predetermined route. You then return and the person or group with the best collection wins. A photo treasure hunt is much the same, only here you have to collect photos, or rather take photos of objects according to the instructions. Again, it may be along a preset route or, to make things a little trickier, within a certain location.

IDEAS FOR SETTING UP A PHOTO TREASURE HUNT

There's no need to be too proscribed about the rules, but here are a few pointers to make the event successful:

• Choose a location that provides great photo opportunities, but also allows you to be a little cunning with the clues. You may want to choose whether your hunters have to follow a course or are allowed to roam at will.
• Think about whether the event will be on foot or will involve driving. For the latter, it's important you plan on teams of at least two people so that one person can concentrate fully on driving.
• Treasure hunts are usually limited in time (to, say, three hours) but are not races – so everyone arriving back in time gets their photos considered. This is an important safety consideration to take into account.
• Determine what you want your teams to photograph. It could be photos of themselves doing things in different places: leapfrogging over posts, balancing on walls, doing impressions of animals at inappropriate locations and so on. Or you may want to provide cryptic clues about buildings or landmarks along the route and get your hunters to decipher them and take the relevant photo. Whatever you do, it should be fun! You could provide very vague suggestions for photos and leave it to the creative minds of the hunters to interpret as they see fit.
• Arrange a start and finish time: at that finish time you can all meet up and you can judge the best collection, or the most imaginative selection, of photos.
• Finish off by presenting the winner with a prize – but it's good to share the photos everyone's taken, perhaps on a Facebook page (or pages) or even on a web photo gallery.

A tricky one: try not to make the clues too cryptic, although there's nothing to stop your contestants using a little extra help such as a guidebook

Clue solved: photo treasure hunts are a great way to get friends to put their cameras through their paces

'Something French': clues like this are open to wide interpretation; give extra marks for the more imaginative responses

THINK ABOUT TIMING

You'll want to run most photo treasure hunts in the daylight –it's obviously easier to shoot the subjects. This doesn't preclude you from scheduling evening or even night events so shooting illuminated or dark subjects becomes part of the fun. Remember that most digital cameras can make a pretty good job of night and low-light photography.

CHOOSING HUNTING TARGETS

As I've said, there can be no limit to your imagination. But to get you started here's a couple of sets of photo targets that have been used to intriguing effect in real hunts. The first is a pretty standard set; the second perhaps a little more esoteric:

Set 1

1. Stained glass
2. Metal gate
3. Something from the eighteenth century
4. A boat (model or full size)
5. A glove puppet
6. Two fishes
7. A reflection
8. A clock
9. The letter 'M'
10. Something new
11. Something hot
12. Something cold
13. Something French
14. A pie
15. A train

Set 2

1. Open
2. Closed
3. Abandoned
4. Heavy
5. Empty
6. Busy
7. Tall
8. Expensive
9. Forgiving
10. Stressed
11. Impressive
12. Standing
13. Giving way
14. Large
15. Formal

All these subjects are open to wide interpretation. 'Giving way'… A ruined building? A road junction? A parent giving way to a spoilt child? The breadth of interpretation is what makes treasure hunts so much fun. And makes finding a winner so difficult.

CLEVER IDEA 63:
SHOOT 3D PHOTOS

Three-dimensional – or stereo – photos are nothing new. However, thanks to movies like *Avatar* and the latest advances in TV design, 3D imagery is now all around and it's perfectly possible to take 3D photos with today's standard digital camera.

SHOOTING 3D PHOTOS

Years ago, 3D photos would have been taken with special stereo cameras, but today you can shoot in 3D using your standard digital camera – whether it's a compact or dSLR. Achieving a 3D effect depends on shooting two photos of a scene from slightly different positions, equating to the view seen from each of our eyes. Here's how:

1. Start by holding your camera in portrait format – 3D photos will work best using this orientation – standing with your weight mainly on your left leg.

2. Shoot your first photo.

3. Now, with the camera still held steadily, transfer your weight to the right foot, moving a few centimetres to the right of your starting position.

4. Then take the second shot.

Now you've taken your two photos or, as 3D enthusiasts call them, a stereo pair.

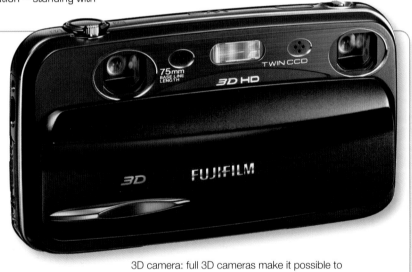

I 3D CAMERAS

If you find yourself bitten by the 3D bug, why not go for a proper 3D camera? Full 3D cameras, like the Fujifilm example shown here, comprise two identical optical systems separated by a distance, similar to that between our eyes, to give the correct perception of depth. The 3D results can be viewed on the special 3D panel. You can also shoot photos of moving subjects, something that's impossible with the consecutive shot process described above.

3D camera: full 3D cameras make it possible to shoot moving subjects as well as static

GETTING THE BEST FROM 3D PHOTOS

The best 3D photos are those with the greatest depth. A 3D photo of distant hills will look little different from a 2D version. However, bring in some foreground interest and something in the middle distance, and you will have a much more powerful shot that takes advantage of the 3D effect.

VIEWING 3D PHOTOS

You've several options when it comes to viewing 3D photos, but first you need to prepare them. When you've downloaded the images you'll probably notice that, although you've changed your position very carefully between shots, they may not be precisely aligned. You can use image-editing software just to nudge the positions and perhaps trim the edges. This is not a critical part of the process as you'll probably get a great 3D effect without these adjustments.

Cross-eyed viewing

There are several ways of viewing your photos, but the cross-eyed method is the easiest as it doesn't need any special equipment. Either print the photos out or display them both on the computer screen, with the photo taken corresponding to your right eye (when your weight was over your right leg) on the left, and the photo corresponding to your left eye on the right. Cross your eyes so that your right eye looks at the left image and vice versa. What you'll see will be three images and the middle one will be in spectacular 3D! Give your eyes a moment to adjust and the effect gets even better.

Straight-eyed viewing

Some people will find it easier to view the two images conventionally, so right-eyed image to the right, left-eyed to the left. To view 3D photos in this way, look at a distant scene and then bring your two photos into your field of vision. Again you'll see three images, the centre one being 3D. Wait for your eyes to adjust and you'll get the full effect; aficionados of 3D photography often say you'll get better perspective this way than with the cross-eyed approach.

3D viewers

Some specialist photographic suppliers can provide the modern equivalent of the old stereograph, letting you view your images without resorting to any eye gymnastics at all. You can mount prints in these and view them through lenses that will correctly overlay them.

Anaglyphs

You've probably seen examples of anaglyph images: they have both images overlaid and tinted, usually in red and cyan. Then you wear the traditional 3D red-cyan glasses to unleash the 3D images in all their glory. You'll need additional software to create your own anaglyphs and, of course, the special glasses for each viewer.

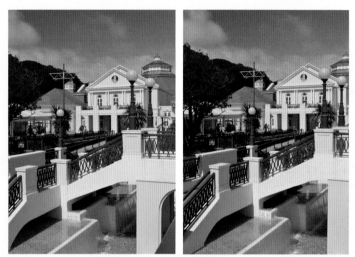

Cross-eyed viewing: this example of a pair of stereo images can be viewed by using the cross-eyed method. Once you've trained your eyes to view in this way, the images spring to life

Straight-eyed image: for this image you need to view with your eyes straight on – left eye looking at the left image and right at the right image

CLEVER IDEA 64:
CREATE STRANGE EFFECTS WITH SIMPLE LENSES

Some cameras have interchangeable lenses; other cameras have fixed lenses that can accept supplementary accessory ones. These accessory lenses can extend your photographic capabilities but come at a cost that can, if you don't intend to use them extensively, be prohibitive.

So, what has a magnifying glass, a front door spyhole, and a pair of reading glasses got in common? They – and others things – can be used as much less costly accessory lenses for your camera. And the effects they produce can be, well, rather wild and wonderful.

Spyhole lens: get that fisheye look with these simple lenses

SPYHOLE LENSES

Designed for front doors – and often found in hotel room doors, too – these lenses create a fisheye effect. This means you'll be able to shoot a full 180 degrees in each direction, capturing everything in front of you with just a single shot. These lenses are designed for a quick look at someone through the door, and are not of photographic quality, so you'll get some obvious distortion – but this is all part of the fun. Use them to shoot portraits and you'll get that back-of-the-spoon look; it becomes more exaggerated as your subject moves closer to the lens.

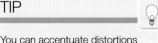

TIP

You can accentuate distortions by tilting the lens slightly relative to the camera.

MAGNIFYING LENSES

Use these to see things very close up. Most digital camera lenses – on compact cameras and camera phones especially – can focus pretty close, but use a magnifying lens (the sort you might use to read really small text) and you can do even better. How do you focus with a lens like this in place? Just rely on the camera. Its focusing system will compensate, although you may have to adjust your position slightly.

READING GLASSES

Like a straight magnifying lens, the lens from a pair of reading glasses can help you get in really close to small objects – and if you use reading glasses you're more likely to be carrying them around with you!

Magnifying lens: get in really close with a simple magnifying lens

BITTEN BY THE BUG?

If you want to go further with this kind of photography, invest in a Lensbaby or a Lensbaby kit. These naïve-looking lenses are specially constructed to produce special optical effects. They aren't as cheap as the other lenses we've looked at but all the same, they're a great deal cheaper than camera manufacturers' own models. And they can do much that other lenses can't.

Eschewing the traditional approach to lenses, Lensbabys are simple, special effects lenses that can bring an unexpected twist – literally – to your photography. Designed by a leading photojournalist, Craig Strong, Lensbaby lenses are designed to bring back some of the fun to photography that conventional lenses – with their ever increasing precision – has stripped away. In fact, you can achieve much of what you might otherwise do with image-editing software, but in-camera instead of in-computer.

There are two great things about these lenses. Firstly they are, compared with conventional optics at least, relatively cheap. And some, like the Single Glass lens are extremely cheap indeed. Secondly, the results can be unpredictable. Here are a few examples:

Single Glass Optic: Want to take moody landscape photos and romantic views of yesteryear? Then this primitive, single lens is just for you. The results can be a bit crude and full of the defects our everyday lenses strive so hard to eradicate, but it can be fun to use, nevertheless.

Lensbaby Composer and Control Freak: Lets you focus precisely on one element of an image – rendering all other areas (even those at the same distance that would normally be in equally sharp focus) as blurred.

Lensbaby Scout+Fisheye: Lets you focus really close (really close!) to the front of the lens keeping virtually everything in sharp focus, while the wide-angle feature means you can take in an incredibly wide view.

Lensbaby: distortion and, as here, zoom-style effects are possible with these lenses

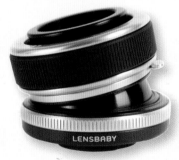

Lensbaby Composer: the tilting front element of the lens is the key to some of the special effects these lenses are capable of – and what distinguishes them

TIP

To attach small lenses to cameras use blu-tack or a similar material, taking care not to touch any of the lens surfaces.

CLEVER IDEA 65:
DISCOVER SCENE MODES

Just about every camera has an auto mode that will configure all the main controls automatically for you – focus, exposure and aperture. On some simple cameras it's the only mode, but if your camera features scene modes you've some brilliant shortcuts to great photography.

Scene modes will configure your camera like a pro's with just a turn of a dial. Think of them as tweaked versions of the auto setting that configures the camera precisely for specific photographic situations. You'll find a range of scene modes on most cameras apart from basic auto-only cameras and, ironically, some professional models.

WHAT SCENE MODES ARE AVAILABLE?

Let's take a look at the scene modes you might find on your camera. The list of modes here is by no means identical to the one that you'll find on your camera. Some modes are, indeed, common to all models; others are not. And your camera may have further modes that are not listed here. The good thing is that all the modes are, for the most part, self-explanatory. For example, for the best portrait photos select portrait mode, and so on:

- Portrait mode
- Landscape mode
- Sports mode
- Beach and snow mode
- Sunrise and sunset modes
- Backlight mode
- Macro mode
- Night portrait mode
- Night scene mode

SELECTING SCENE MODES

If your camera has them, where are you able to access them? Often this is done via a selection dial on the top of the camera; simply rotate the dial to the chosen scene mode. On other cameras you can select them via the menu system; not quite as quick to set as the dial method, but once you get familiar with the process, pretty simple.

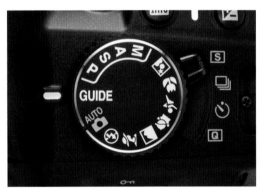

Scene mode dial: here the scene modes, indicated by icons, are arranged on a dial. To select, simply turn the dial to the respective mode

Scene mode menu: on some cameras you'll select the scene mode via a menu, as shown here

CLEVER IDEA 66:
GREAT PORTRAITS WITH PORTRAIT MODE

In Chapter 1 we talked about starting to get to grips with taking great portraits of children and pets. Getting familiar with the portrait scene mode completes the process by configuring your camera to deliver the best results for any kind of portrait shot.

TIP

Get better results by applying a bit of fill-in flash from the camera's flash controls, even if shooting in good light. This provides a small amount of flash lighting, enough to lighten any shadows on your subject's face.

(I) HOW DOES PORTRAIT MODE WORK?

So what does the portrait scene mode do to your camera and how does it help you capture those great portraits? Actually, it's mostly about getting the lens settings right. In this mode your camera lens is set so that your subject will be in sharp focus but the background, or anything additional in the foreground, will be blurred, thereby emphasizing your subject. The zoom setting will also be set to medium telephoto; this shows your subject off to best advantage and helps avoid the back-of-the-spoon effect you often get when shooting with the zoom at its standard or wide-angle setting.

At the same time, other camera settings will be adjusted to optimize these lens configurations. In practice this means that the lens aperture will be opened as wide as practicable, to limit the focus to just the subject. This leads to short exposure times, meaning you can usually hand-hold your camera successfully.

Great portraits: in portrait mode the background is thrown out of focus so it does not compete with the subject for attention; the lens is also adjusted to a moderate telephoto setting

CLEVER IDEA 67:
GO SOFT ON YOUR PORTRAITS

Here's a great way to give your portraits a soft, dreamy effect. Professional photographers call this 'soft focus' and spend a fortune on specialized filters to achieve it.

Instead, stretch a piece of cling film tightly over the front of your lens, making sure it doesn't actually touch the lens. The tighter you stretch it, the more subtle the effect. Experiment by making a small hole in the film; this can lead to an even more subtle effect.

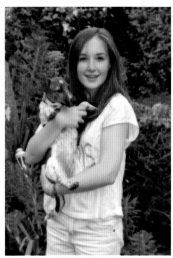

Soft focus: an inexpensive piece of cling film can give results akin to expensive soft focus filters and produce really flattering portraits

CLEVER IDEA 68:
GET FAMILIAR WITH MORE SCENE MODES

Scene modes provide great shortcuts to help you configure your camera like a pro, without having to remember all those tedious settings. Better still, on some cameras you are able to set the camera in ways that the manual controls alone don't allow. Get to know your available scene modes and get to love them. Here are a few more of our favourites:

LANDSCAPE MODE

Use the landscape scene mode to guarantee you pin-sharp landscape shots, with everything from nearby objects to the horizon in sharp focus.

• **What it does:** Sets the camera's lens to keep as much of a scene in focus as possible – from the foreground to a distant horizon.

• **Best for:** Wide, scenic landscape views, cityscapes, and other situations where you may want as much of the scene as possible in focus.

TIP

Getting the maximum range in focus means the lens of the camera uses a small aperture. This means long exposures that could, in turn, lead to blurred photos. Consider using a tripod or propping your camera up against a sturdy support for best results.

Landscape mode: unlike the portrait mode that limits the range of sharp focus, selecting landscape mode extends it to the maximum possible, from nearby to the far distance

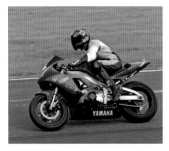

SPORTS MODE

Earlier in the book we looked at some clever ways to shoot action sports. The sports scene mode is ideal for helping you with those shots, freezing fast-moving subjects and keeping them in sharp focus. It's called action mode on some cameras.

• **What it does:** Selects a fast shutter speed so fast-moving subjects are captured as sharply as possible. Some cameras will also keep the focus system 'live', so that as your subject moves towards – or away from – the camera, it remains in focus.

• **Best for:** Sporting events or anything that moves fast.

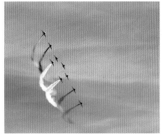

Sports mode: fast-moving subjects can easily lose focus and become blurred unless a 'fast' setting such as sports mode is selected

TIP

With very fast-moving subjects, even the sports mode may not be able to freeze them. You can get better results by panning the camera – following the subject – and keeping it centrally within the frame.

BEACH AND SNOW MODE

Variously called 'beach' or 'snow' modes on different cameras, this overrides the tendency of the camera exposure meter to assume everything has a medium reflectivity, and takes perfect exposures in bright, sandy conditions or against white snow.

• **What it does:** Adjusts the camera's exposure system so that it technically overexposes (renders a scene too light). This compensates for the higher reflectivity of snow and beach scenes.

• **Best for:** Any snowscapes, and sandy beaches, lakes and seascapes on sunny days.

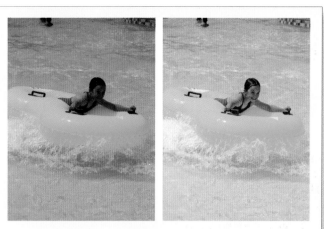

Beach and snow mode: when using conventional auto settings, snow and sand-dominated shots can be dull and lacklustre. Selecting this scene mode gives your photos that little 'lift'

Night portrait mode: this ensures you get a perfect balance between the ambient lighting at night and the flash-lit nearby subjects

NIGHT PORTRAIT MODE

This mode takes an accurately exposed portrait shot of subjects at night against equally well-exposed city backgrounds.

• **What it does:** Sets a longer exposure suitable for accurately recording a scene such as a cityscape at night. It combines this with a burst of flashlight from the flashgun to correctly expose the subjects.

• **Best for:** Tourist-style shots of people standing in front of floodlit landscapes.

TIP

Although a tripod is not required for flash shots generally, it is recommended in this case, as the exposure required to capture the background is somewhat long for hand-held shots.

BACKLIGHT MODE

This mode avoids subjects being reduced to shadows or silhouettes when shooting towards the sun or a bright light source.

• **What it does:** Avoids subjects taking on a silhouette form when shot with the light behind them.

• **Best for:** Portraits – particularly of small groups or individuals – when the sun is behind and it's impossible to re-arrange the scene.

Backlight mode: shooting towards the sun or a bright light can render your subjects as dark silhouettes. The backlight mode will create more consistent lighting across the image

CLEVER IDEA 69:
SHOOT THE SEASONS

The seasons provide some great opportunities for taking photos; successfully capture them with these few key tips and ideas for each one:

WINTER

At this time of year short days and low temperatures would seem to conspire against successful photography, but in actual fact both make for great photo opportunities. Here are some to capitalize on:

Snow: Totally transforms the landscape into a fantastic photo opportunity, but the brightness of the reflected light can fool some cameras. Achieve the best results by either using the snow and/or sand scene mode, or set the camera to overexpose slightly. Overexposing will ensure that snow doesn't become dark and murky looking.

Frost: More delicate and ephemeral than snow, you'll have to get up early to get the best shots of this. Overexpose as you might for snow, and look out for the low sun which can often cause further underexposure – not necessarily a bad thing – leading to some great effects.

A festival of lights: Lots of faiths and cultures enliven the darkest days of winter with festivals of lights. Christmas, Diwali, Hanukkah and so on, all break the gloom of the darkest days with distinctive light shows. You can easily record these with your camera, and you can record many of them successfully by setting it to auto mode. Experiment by underexposing to capture the colour of the lights to best effect.

Snow shots: nothing says 'winter' better than snow shots, but overexpose to avoid photos becoming grey, as shown in the inset

Christmas lights: cities and homes become festooned in a blaze of colour and form for the Christmas holidays, and this is easy to record with your digital camera

Winter activities: Often piggybacking on Christmas celebrations, features like ice rinks are increasingly common during the shortest days. Shoot them on auto mode, perhaps experimenting with fill-in or direct flash to best capture people skating and enjoying other winter activities.

Winter activities: organized or impromptu, these are great to photograph

SPRING

As the days lengthen, the landscape – literally – springs back to life. Make the best of the extended daylight by capturing the essence of this season:

Fauna and flora: As hibernating and migrating wildlife reappear, the landscape around them begins to turn green and spring flowers burst into life. All make for wonderful spring photos either on their own or as a backdrop to photos of family members, especially children.

Weather: The 'April showers' may not have the same resonance for inhabitants of the southern hemisphere, but showery weather mixed with strengthening sunlight makes for great photos in any location – and provides the best opportunity for rainbows.

Easter: Now something of a portmanteau word for spring celebrations rather than a religious event, the Easter holidays are perfect for shooting family and community activities. Children's egg hunts, parties with Easter bunnies and more, make for superb – and very seasonal – photos.

SHOOTING RAINBOWS

Get the best chance of shooting a rainbow by knowing where and when to shoot them:

• The arc of a rainbow always occurs opposite the sun, so turn your back to the sun to be ready to spot them.

• Rainbows occur when sunlight falls on the raindrops, so you need showery weather with sufficient blue sky between shower clouds.

• Look out for second or third rainbows (which may not be complete arcs) outside the main rainbow in brighter light.

• Rainbows can also occur in the spray from waterfalls and mists – watch out for them in these conditions.

• Ice crystals in the upper atmosphere can produce more elusive arcs and bows closer to the sun.

Rainbow: those induced by waterfalls make a perfect backdrop to informal shots like this

SUMMER

The lion's share of photos are shot in the summer months. Long days, bright colours, holidays and events are all a gift for the photographer. Even, I suspect, a large number of professional photographers will admit that their personal photos show a bias towards being taken during this season. And why not? Summer just can't be beaten. Here are some ideas to capture the best of it:

Holidays: Some people only use their cameras twice a year – at Christmas and on their holidays. Holidays are a gift for photographers of all kinds: you have fantastic new locations to record, plus you're sharing the event with friends and family. Shoot everything and anything that you can – there's nothing more disappointing than returning from a dream holiday and thinking 'if only…'

Don't forget that if you're in really bright conditions – such as on a beach or in snow – your camera can overcompensate and underexpose your shots, leading to disappointingly dull photos. Follow the winter advice about selecting an appropriate scene mode or overexposing manually.

Events: Good weather is perfect for a whole range of activities and events. Make sure you always have your camera on hand.

Weather: Bright blue sky may not be ideal for professional photographers because of its harshness, but it's great for enlivening all manner of subjects. As clouds develop during the day they can start to produce dramatic skies that add drama to the most mundane subjects.

Summer colour: Plants, flowers and, indeed, many people (in a dress sense) are at their most colourful in the summer months. Scenes that might, at other times of the year, be rather grey or monochromatic suddenly explode into every conceivable hue.

Summer events: balloon fiestas are ablaze with colour and somewhat surreal shapes, and there are many more colourful summer events to explore

ⓘ USING FLASH IN THE SUMMER

You might expect that with the high light levels of summer there would be no need to ever use your camera's flash. But flashlight can be a useful adjunct to harsh sunlight. When the sun is bright and high in the sky, it can cast overpowering shadows that can be unflattering when you're shooting people. Use the camera's flash and you can lighten these shadows. For best results choose the fill-in flash mode – this carefully balances flashlight levels with daylight.

Summer colour: you can be spoilt for choice when it comes to summer colour. For best results don't try and shoot colourful plants, for example, all in one go – a few selected colours work better than a potpourri of every hue

AUTUMN

Autumn is arguably the most diverse of seasons as it provides the visual link between late summer and the returning winter. In many locations the most disappointing weather and greys can predominate, but don't let that be an obstacle to collecting some great shots:

Leaf fall: The leaves of deciduous plants can go though a wide gamut of colour changes throughout the autumn, each as photogenic as the next. Some trees – acers and maples, for example – are more ebullient in their colour changes and make ideal subjects or backdrops for formal or informal portraits.

Autumn colour: autumn leaf colours can change on an almost daily basis, but more so after dry spells or early frosts

Sunsets: Don't restrict your attempts at shooting sunsets to just autumn months, but often the weather patterns make for more colourful or dramatic shots at this time of year. The same applies to sunrise, of course, but until winter makes the hour of sunrise more sociable, it takes an added degree of dedication to get up so early.

Sunsets: a perennial favourite for their colour that can be emphasized by a modest degree of underexposure

RECORD THE CHANGES

Shoot photos of the same scene at different times of the year. Choose different weather conditions and times of day, too. As well as making for a great talking point, you'll start to see how profound the changes can be in the landscape. You don't, of course, need to mount your camera on a tripod and leave it in that position all year. Just choose a scene that you can easily shoot repeatedly – for example, the view from a window or your garden – and set the camera lens to the same focal length each time.

CLEVER IDEA 70:
SHOOT A TIME-LAPSE VIDEO

Still video cameras and camera phones can all generally shoot normal video, and will grab you some pretty reasonable movie footage. But you can get some more intriguing results by using the still-image capabilities on these devices. We've all seen time-lapse videos: the life cycle of a plant played out in a couple of minutes, or a skyscraper growing skyward at a storey per second. You can create similarly time-defying movies yourself with even the simplest of cameras that allow you to shoot images at specified intervals. On the more simple cameras you'll have to set these intervals yourself; more sophisticated models will let you program the camera to take a shot at pre-determined intervals.

CHOOSING A SUBJECT

Begin by choosing a subject. Shooting a time-lapse movie relies on taking a single image at regular periods over the duration of the event you want to record. If you go for an ambitious event this can be quite a commitment, so begin with something more modest, such as the changing skies outside your window or traffic flowing along a major road.

SHOOTING YOUR IMAGES

Mount your camera firmly in front of your subject. Shoot away at your chosen frequency, whether one frame a second, one frame a minute, or whatever. Just remember, the camera – and you – need to stay put throughout the process; this means you can't nip out for lunch.

ⓘ COMPRESSING TIME

Normal video comprises between 25 and 30 images per second; anything less than around 15 images per second and motion can appear jerky. So aim to shoot at least 15 images for each second of video – you can see why shooting long time lapse videos can be quite a commitment! So, shooting at 20 images – or frames – per second, you'll need to shoot 200 photos for ten seconds of video, and 1,200 photos for a full minute of movie footage.

So, how does this 'compress time'? Well, if you shoot one frame every second, this means that one minute's live action will replay in three seconds if replayed at 20 frames per second. Shoot one frame a *minute* and that three seconds of movie will represent an hour in the real world. Calculate the rate you need to shoot to record your subject, and don't aim for anything too ambitious – a five second movie can be quite compelling.

COMPILING A MOVIE

You can assemble your still images into a movie using freely available software. Mac users can use the excellent iMovie, included in the software bundle of Mac computers. Similarly, Windows users can use Windows Live Movie Maker. Commercial software applications are also available and enable you to create more ambitious productions. You'll need to import your images into your chosen application and then, in sequence, add them to the movie

A year in the life: perhaps the ultimate in time-lapse shooting, here a whole year in the life of a landscape has been recorded

timeline. Select each display for a single movie frame if you want to work at the default 25 frames per second – that's all there is to it. Once you've pulled all your images into the video timeline you can review the results and, if you like them, export the results as a movie.

USING A TIMER

Some cameras have, built into them or available as an accessory, timers that will take sequential shots for you. These will precisely shoot at pre-determined intervals for as long as you want. Perfect for those ambitious time-lapse blockbusters!

CLEVER IDEA 71:
SHOOT A FLICKBOOK VIDEO

TIP

You can shoot flickbook movies freehand, without mounting the camera on a tripod. In fact, camera movement can often be an important element in the movie.

A flickbook-style movie is similar to a time-lapse one, but is more obviously made of individual images. Think of it as a sequence of still images shot in real time that, when played out as a movie, confer movement. And rather than shooting 20 or more photos for a single second of movie, a flickbook movie might comprise one, or maybe two photos per second of movie. It's really a high-speed slide show, with each slide following on from the previous one.

SHOOTING AND ASSEMBLING YOUR FLICKBOOK MOVIE

What can you shoot? Well, just about anything: your journey to work, children at play, or a night out with friends. Although you'd shoot photos at, say, one per second, you don't need to shoot every second. And you can change the camera angle modestly between shots for added interest. To assemble your movie, it's essentially the same process as outlined for time-lapse movies. Rather than one frame for each image, display each for, say, half a second or, perhaps, 10 or 15 frames.

Flickbook movie – slow: shooting one frame every second or two gives progressive movement

Flickbook movie – fast: shooting one frame every half or quarter second produces smoother motion yet still preserves the flickbook effect

CLEVER IDEA 72:
BACK UP YOUR PHOTOS

When your photos are digital, it can be easier to lose them – or lose track of them – if you don't take some basic precautions How often do you back up your photos currently or, indeed, back up anything on your computer? Chances are, your answer will be rarely – or maybe never.

SAFETY FIRST

Those people that do back up regularly have probably learned by hard experience the folly of not doing so. Back in the days of film-based photography you had something physical to deal with: prints, negatives or slides. It was easy to keep tabs on them and losses, except in extreme circumstances, would be rare.

Digital images are more ephemeral – computer discs can fail, files can be written over. There are just too many ways you could lose your precious images. So what can we do to ensure our digital images are as safe as can be? I'm afraid this does mean backing up – but that term doesn't necessarily need to infer a laborious process.

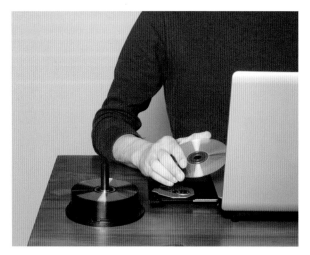

Back up discs: backing up to CD or DVD discs is an excellent way of creating an archive that you can store away safely.

SET A REGIME

It's important to get yourself into the habit of backing up your photos to keep them safe. Here are some of the methods many photographers follow:

• Each day, download the photos from your camera's memory card to a computer.

• Don't delete the images on the card unless you are sure that you've got a good copy of them all on your computer. Some applications that download images conclude with the option 'Delete all images on camera/phone?'. I'd say 'no' to that until you've checked the photos have successfully downloaded.

• Make a second copy as soon as you can to a separate hard drive or even to an online library. There are now many services that offer online storage – admittedly, often at a cost in the case of large libraries – that makes your images available anywhere. This can be very useful when you want to show them off.

• If you've made a couple of archive copies, keep them in different places. You don't want to think the worst, but if theft or fire means you lose one, the other will still be safe.

Of course, you don't have to follow this regime, or follow it precisely. And you can often set your camera to copy images to your computer automatically each time you connect it.

KEEPING TABS ON YOUR PHOTOS

Because, thanks to digital photography, you can now shoot all day without stopping, you can quickly end up with a large number of photos. This means that finding a specific one can quickly become difficult. Pro photographers use cataloguing software that can help instant identification – it's great for image retrieval, but tedious to work through the cataloguing process.

Almost equally effective is to use a computer application that will keep your photos together by shooting date and/ or subjects. Popular examples are iPhoto on Macs, and Adobe Photoshop Element's Album feature. Often these apps also make it easy to arrange your photo collection into folders and albums, too.

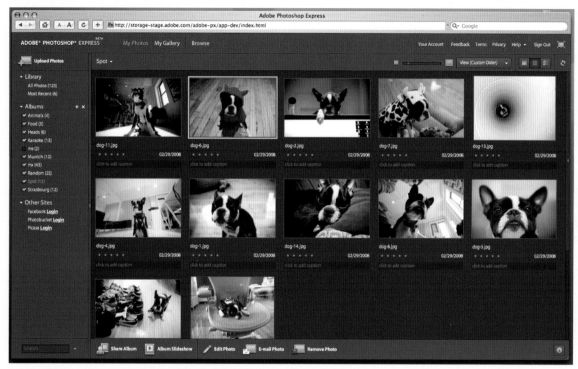

Cataloguing images: using a simple application (like Photoshop Express here) you can store all images in one place and sort them into albums and events – and even share them with select friends and family

BACKING UP ON THE MOVE

If you're travelling, you may not have a computer with you on which to back up your images. Instead, consider investing in a hard drive that lets you download images without connecting to a computer. Relatively cheap, they're more than worth it for the peace of mind they bring. Or, if you have the chance, you could back up to an online library.

Back up drive: devices like this, from Epson, let you back up your memory cards on extended travels. A built-in screen even lets you review and delete images

CLEVER IDEA 73:
MAKE PHOTOS FUTURE SAFE

TIP

If you have a need for a low, or lower, resolution version of a photo, make a copy of the high-resolution image on your computer first. This means that you can resize it at will with the assurance that the original is intact.

Here's a great idea whose benefits may not be immediately obvious. It's a concept that has been passed down to us by the early adopters of digital photography.

Not so long ago, when digital cameras were not that great, the early adopters of the medium shot plenty of photos that were reasonably good. However, many of these images were taken at low resolution to ensure as many images as possible could be recorded on the low capacity and expensive memory cards. They were also shot using imaging chips – the digital equivalent of film – that were limited in the range of contrast they could record. Although those photos looked OK then, when they are compared with contemporary shots their mediocrity is obvious. But often hidden away in those shots is detail and quality that, with more recent software, we can extract to deliver more dynamic images.

How does all this relate to making your photography today future-safe? Well, it's virtually certain that advances in photo technology and photo software will mean that photos taken today will, in the future, also deliver better quality. So, it makes sense to ensure that when you shoot photos today you do so with an eye to what might be possible in the years to come. Of course, crystal ball predictions have no place in photography and many of the advances that we've seen over a comparatively short period of time would not have been predicted. But there are some basic steps you can take to make sure that you don't just have the best image quality today, but the basis for creating even better photos in the future.

TIPS FOR SHOOTING FUTURE-SAFE IMAGES

Resolution: Memory cards for your camera are reasonably cheap so make sure that you shoot whenever you can – if not always – at the highest quality. You may not need a high-resolution image of your subject now (perhaps you're just shooting to email a photo, or to use on a website) but you might well regret not having one in the years to come. If you need them, create lower resolution images from larger originals.

Shoot RAW: You may not want to use this for absolutely every shot, but for those important photos – or those you expect to use again and again – shooting in RAW format gives you the best chance of squeezing out the very best in quality. Not all cameras offer this mode and those that do often let you shoot a conventional JPEG image – for day-to-day use – too.

Shoot lots: We've said this many times before, but the comment is equally valid here. Unless an image is obviously poor – because it is poorly framed, blurred, or whatever – it makes sense to keep hold of it.

Shoot lots: don't ever regret taking those extra photos

Resolution: shooting at a low resolution means you can get more photos on a memory card that look fine when viewed on a camera, but when you come to enlarge them later you'll be disappointed. Shooting at high resolution avoids this problem and gives you more freedom for image usage

(I) SHOOTING RAW

A RAW image is an image file that has not been processed by the camera in an attempt to make it look its best. RAW files need a bit of post-processing using image-editing software but, if you are adept at this, the results can be stunning. And who knows, in the future image-editing apps may be able to do much of this automatically.

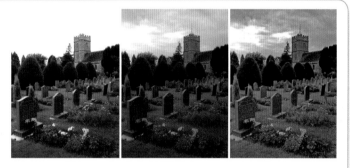

RAW images: a RAW image (left) contains a lot of information that can be coaxed out using RAW image processing software (centre, right)

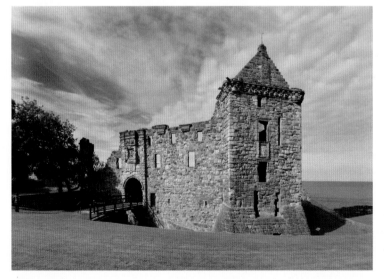

HDR: high dynamic range photos are currently very much in vogue. These are produced by combining three photos; one underexposed, one overexposed and one correctly exposed

HDR

HDR – high dynamic range – photos are very much in vogue right now. To produce them, three photos are combined: one underexposed, one overexposed and one correctly exposed. The combined version takes the best parts of all three to produce an image where shadow detail from the over-exposed shot is combined with sky detail in the underexposed one. The result is a photo that has detail in all parts of the image, something normally impossible in a single shot. Photographers who shot series of photos like this in the past have been able to create these stunning images once the technique became viable.

Isle of M
Summe
2010

Around Blair Castle, Blair Athol **35**

CHAPTER 4:
ENJOY AND SHARE YOUR PHOTOS

There was a time when your best photos were destined to a mediocre future. If they were lucky they would get their brief moment of fame mounted in an album, then they would be left to gather dust in a bookcase, only occasionally brought out to see the light of day. Those that didn't make it to the album would be left in processors' envelopes or would be dumped, probably under a bed in an old shoebox. This is hardly the way to make the most of treasured memories.

Thankfully, today our images can look forward to a much more illustrious future. Their digital nature means they can be distributed widely and easily,

for example on websites and blogs. And they can be printed in so many different ways. Where you could once look forward to using your best images for a modest range of products including large prints, calendar illustrations or T-shirt designs, advances in digital printing techniques now provide much greater scope. You can print on almost anything in virtually any size. We'll explore some of the possibilities here.

Whether you choose to create and produce prints at home, or broaden your creative horizons by employing a photofinishing studio, let's take a look at just some of the clever ways you can enjoy and share your photos.

CLEVER IDEA 74:
SHARE PHOTOS ONLINE

You've taken some great photos and you want to share them. You can replay them straight back on your camera, but what if you want to share them more widely? You could email them on to all your friends and family. This is a simple way of sharing photos, but is not to be advised. An email with loads of photos attached can fill recipients' mailboxes and will not win you fans. Better to create your own web-based photo album and let everyone share your images there.

A great site – although not the only one – is Flickr (www.flickr.com). Flickr lets you upload your photos and then share them, either within Flickr's own web galleries or though social networking sites. So you can upload your favourite photos once and then share them all over the web. The great thing about Flickr is that basic accounts, which are fine for most users, are free. And even if you become a power user the cost is modest.

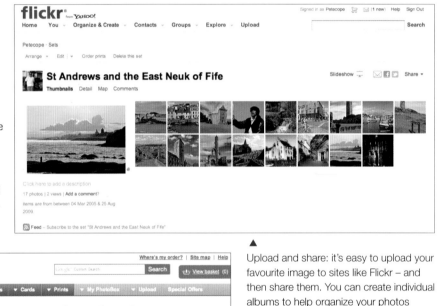

▲
Upload and share: it's easy to upload your favourite image to sites like Flickr – and then share them. You can create individual albums to help organize your photos

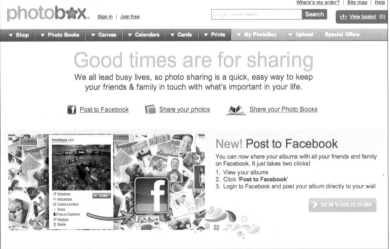

◀ Order prints: some photo sharing websites also let you – or anyone who views them – order prints from favourite photos

A still image version of Flickr: here you can share photo albums in situ or you can link to them from other websites

TIPS FOR SHARING PHOTOS IN AN ONLINE GALLERY

• Select only your best photos when displaying them in a gallery. Visitors won't always appreciate seeing lots of very similar photos.

• You don't have to make your web photo galleries totally public. Most sites let you restrict visibility to just those you select to see them.

• Sites like Flickr let you join 'groups' to share your photos with others who enjoy similar interests. This also creates a great opportunity to receive useful tips and critique on your photos.

QUICK-FIRE SHARING ON SOCIAL NETWORKING SITES

For a quick way to share photos you can upload them directly to social networking sites. This can be even faster if you have a camera phone that has a Facebook app; you can take a photo from the app and share it on Facebook within seconds.

Instant share: photos can be uploaded directly from many smartphones to social networking sites so you can share them with your friends instantly

Kayaking at Niarbyl
Report as inappropriate

5 of 1042 Go to photo No. [] Go

POST YOUR TRAVEL SHOTS TO TRAVEL REVIEW SITES

There's no need to limit your photos to just albums and social networking sites. You can use them to illustrate your online blogs and even websites. Or if you've taken some great shots of your travels and outings, why not add photos to reviews? Sites like TripAdvisor (www.tripadvisor.co.uk) just love you to illustrate your reviews as these often candid images can prove useful to other travellers.

A picture is worth a thousand words: on sites like TripAdvisor, people can see the best and the worst for themselves

101

SHARE PHOTOS ON YOUR OWN WEBSITE

It's fantastic being able to share photos on the internet, but why not showcase them properly using a website of your own? It's surprising, but even computer enthusiasts often baulk at the idea of creating their own website. And there's a good reason for that. It's not been that long since creating websites required skills in programming **HTML** – the language of websites. While not exactly difficult, mastering the language could prove quite an obstacle to getting started.

CREATE YOUR OWN WEBSITE

You can put all that behind you today as it's now quite feasible to create a website without knowing anything about HTML or, indeed, any other computer language. There are now many online sites that let you create your own website from scratch. A popular one is Weebly (www. weebly.com), although there are plenty of others too. The great thing is that joining Weebly to create a basic website, quite sufficient for most needs, is free. Here's how to create a website using Weebly to show off your photos:

1. Create an account with Weebly. This is easy and just requires a name, an email address and a password.

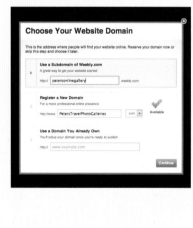

2. Think of a meaningful title for your website. You can also choose the type of website. Here, as we are going to display photos, we've chosen 'portfolio'.

3. Now, create a domain for your website. This needs to include the URL – or address – you'll go to when you visit the site: the www.bit. You can create your own: here we've called it www. petersonlinegallery. weebly.com

4. Start creating your website. On this page you can choose templates and colour schemes, and add the appropriate text.

6. You can now click on the Gallery button and add images.

5. Here's our Travel Photos website. We've chosen a dark colour scheme and then added the name and description. We've also added a Gallery option.

7. Job done! Now your images are uploaded and, after you press the Publish button, they are available for all to see.

8. You can visit the URL (the www. name of your website) and see your website 'live' on the internet.

Of course, what we have created here is a very basic website. For a start, it only has one page. The chances are your photo collection will quickly outgrow a single page and you'll want to extend over several pages. That's simple to do, too – you can add pages like the one we created here or, perhaps more logically, you could have a front page – a home page – that has a list (or thumbnail images) that will take you on to other, subsidiary pages.

Adding pages: it's easy to add pages to a website. Here in Weebly you simply click on Add Pages, give the new page, or pages, a name, and they'll then appear on the front – home – page where you can link directly to them

LETTING PEOPLE KNOW ABOUT YOUR SITE

Once you've created your site you'll want to let everyone know about it – after all, you created it to share. Weebly makes this easy: each time you publish your site – or publish changes and additions – it lets you share the changes via Twitter. This means you can automatically tweet to all your friends and followers that you've added something new.

GOOGLE ANALYTICS

Are you curious about who is visiting your website? Where in the world they might come from? How often do they visit and from what pages? You can find out all this information – and more – by signing up to Google Analytics. This is a free service that will let you discover all the statistics about visitors to your website. It is very clever and very revealing.

CLEVER IDEA 76:
ADD BORDERS AND FRAMES

Buy a commercial print and it's often presented in a frame with a mount that, together, make the artwork itself look even better – and, if we're being a bit cynical, worth the price. Wedding and other social photographers also realize that customers are more likely to buy a print when it's presented in a frame – or even a simple folder. We can use this simple principle to dramatically improve the appearance of our own photos.

Often, though, just giving a print a neat border can make it look so much more effective particularly, for example, when presented in a simple clip frame. Adding a border to a special photo is simple and can quickly enhance it, whether you are aiming to print it, display it, or even post it to a website. Try out these clever ways to give your photos an added lift with a customized border.

PHOTOSHOP EXPRESS

Many apps let you add borders to your images – Photoshop Express is a good example of these. You'll find the border effects in the Effects and Borders menu (look for the three stars in the top menu bar). Photoshop Express lets you add a simple white border or one of half a dozen or so alternatives. Other applications give you even more, but I usually find that anything too ornate or graphic tends to compete with the photo for the viewer's attention.

Adding borders: Photoshop Express provides you with a selection of subtle borders

Border styles: borders range from the simple to the complex. Always bear in mind the photo itself and chose something that complements, rather than competes, with it

ADDING A KEY LINE

A great way of enhancing a border is to add a key line as well, a very fine line that surrounds the image itself. Before digital technology, it was difficult to do this with accuracy and many photographers resorted to the dodge of using an opaque black or white pen. Digitally, you can create one using most image-editing applications. Here's how:

1. We'll add a black border and a white key line to this image. You could equally add a white border and black key line, or any other colour combination. In your image-editing software, locate the Canvas Size command. Select 'white' as the canvas colour and increase its size modestly. Do make sure you increase the canvas size – which adds an extra border to the image – rather than the image size which merely enlarges the image. Key lines should be fine, so perhaps increase the canvas by 3 to 4mm ($\frac{1}{8}$in).

2. Apply the change: if you look closely you'll see you've added a fine white line around your image. If you think it's too thick or too thin, you can step back and change it.

3. Now let's add the black border. Repeat the process of extending the border of the image using the Canvas Size command, this time selecting black as the canvas colour and extending the canvas by around 2–3cm ($\frac{3}{4}$–$\frac{1}{4}$in). Here's the result.

ADDING A FRAME

You can go one step further and add a frame to your photos digitally. You'll find most imaging applications have this feature and it's fiendishly easy to apply. Frames, in effect, are just borders with a little texture applied to make them emulate conventional frame finishes such as gilded wood. You can also choose to add a mount, too.

Using iPhoto, choose your photo and select Print. The print window lets you add a simple border, a mount, a frame, or a frame and mount then preview the result. You can vary the colour and size of the frame and the mount by selecting the corresponding items from the icons beside the image. When you're happy, select Print. Your chosen image, and frame, will be printed.

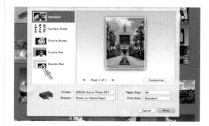

Getting started: in iPhoto, the print window lets you add simple borders, mounts and frames

Digital frames: the great thing is that they have a 3D appearance so, even if you mount them in a simple glass frame, the results can look much more expensive

CLEVER IDEA 77:

IMPROVE PHOTOS BY CROPPING AND STRAIGHTENING

Sometimes when you grab a shot you just don't have a chance to get everything right. You may not get the camera precisely level, or your lens or zoom may not be set correctly. To give your photo impact you can easily correct these shortcomings.

CROPPING PHOTOS

If you've shot your image with the wrong lens attached, or you've not precisely adjusted the zoom, you can end up with a photo of your subject surrounded by lots of empty space. Often, too, we can be so preoccupied with our subject that we don't get the framing correct.

Either way, we find ourselves needing to trim away the superfluous bits around the edges – a process photographers call cropping. You can either crop your images in-camera, on your camera phone, or later using your computer. Whichever method you choose, you need to follow the same procedure:

1. Take a look at the image. Does it need to be cropped? Never crop just for cropping's sake. Some subjects work best when viewed in context in their surroundings, however this image could benefit from some judicious cropping.

2. Use the cropping tool (on your camera, camera phone or software app) to define the area of the image you want to keep. You can refine the crop by adjusting the corner points until you get it just right.

3. Apply the crop: in this case much of the distracting background has been taken away so the image becomes a stronger portrait.

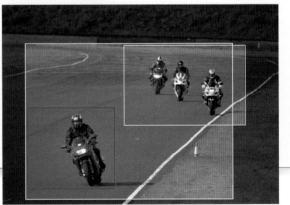

Different crops: sometimes one image can yield two or more cropped images, each with a subtly different character

TIP

It's always a good idea to keep the original of any image you crop, just in case you discover later that you've cropped away something you shouldn't have.

THE RULE OF THIRDS

This is a principle of composition that photographers tend to use all the time. Imagine a grid on your image that divides it horizontally and vertically into three. Crop the image so that key subjects and lines – such as the horizon – are along these dividing lines. It will help you to produce very powerfully composed images.

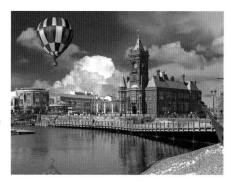

Rule of thirds: this has been used in the creation of this shot and is an easy way of achieving very powerfully composed photos

STRAIGHTENING PHOTOS

Straightening a slanting image is best done on a computer. You need to use the Rotate Image command to rotate the whole image until obvious vertical or horizontal lines are properly aligned with the top and bottom edges of the photo. You'll then need to trim back the photo to get a clean edge. Let's work through the process:

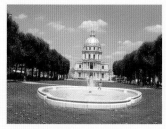

1. Here's the original image. It's clear that I wasn't paying proper attention to holding the camera level!

2. Select the Transform or Rotate command (depending on which software you are using) and apply an appropriate rotation. This may take a little trial and error, although some apps have tools to help you with it.

3. Apply the transformation: you'll then need to trim back the image to remove the extra bits left by the rotation process.

ON A LEVEL

You can try to keep the horizontals and verticals as sharp as you can in-camera by loading your camera phone with a spirit level app.

Spirit level apps: you'll find a range of these available for most smartphones

No more sloping horizons: a simple app can ensure your shots are shot squarely

CLEVER IDEA 78:
CREATE A PHOTOBOOK

Digital technology has brought about many changes for camera users. You can view your photos immediately; you can take as many as you like without having to monitor film supplies; and you can print your favourite photos in amazing quality on your desktop printer.

You might think that sticking those photos into a traditional album is now a little old-hat, and you'd be right. Nowadays you can produce a professionally bound photobook. This is much more robust – and impressive – than an album. Many companies offer photobook services and, broadly speaking, the process is much the same. Here's a summary of the steps involved:

SELECT YOUR IMAGES

Choose the photos you want to include in your book. You may want to choose a theme, such as a holiday, a special event, or a person. Be selective with your photos – for impact, it's better to showcase fewer good photos than more average ones. It'll make the task of creating the book simpler if you also ensure you put the photos into the sequence that you'll use for the book.

EDIT YOUR IMAGES

Used straight from your camera, your images may be completely perfect. You may want to crop some to edit out superfluous details, or you may want to enhance the colour. You can do these sort of edits in any image-editing application, although if you don't have this software, some photobook creation applications allow you to crop or enhance photos as you build your book.

CHOOSE A STYLE AND THEME

You'll be spoilt for choice when it comes to the style of your photobook. In terms of size you'll be able to choose from postcard size through to A3 and larger. You can choose glossy covers or cloth – or even leather for a really special event.

As well as style, you'll be able to choose a theme that will determine the look and feel of the book. You may want to choose an informal theme for a family event, or a travel theme for a holiday photobook. You'll also find themes suited to weddings, and more serious formats designed to show off your arty photos.

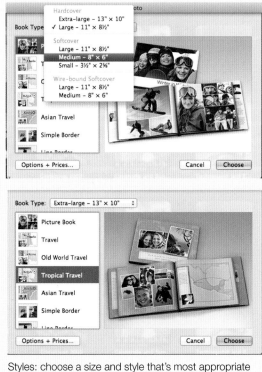

Styles: choose a size and style that's most appropriate to your photobook

COMPILE YOUR BOOK

The style and theme you choose for your book will extend to the pages and the page layouts. You can choose the number of photos you want to appear on each page – from a double page panorama to, say, nine smaller prints per page. You'll generally find varying the style and number of images per page produces the most pleasing result. And make those really impressive shots as large as possible.

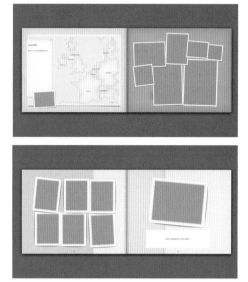

Page templates: these reflect the style and theme chosen

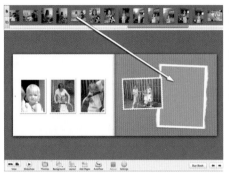

Add photos: adding photos to a template page is a simple drag-and-drop process. If you change your mind, you can simply drag an alternate image to replace the current

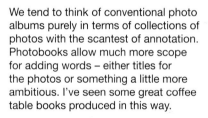

Page layout: you can vary the number of photos on each page and the layout of those images

TEXT AND COMMENTARY

We tend to think of conventional photo albums purely in terms of collections of photos with the scantest of annotation. Photobooks allow much more scope for adding words – either titles for the photos or something a little more ambitious. I've seen some great coffee table books produced in this way.

PUBLISH YOUR BOOK

Once you're happy with the layout (and it makes sense to review it a couple of times to be sure) you can upload your book for printing. This can take a few minutes. Printing your book takes a little longer and, with return postage, may take up to a week. But it'll be worth the wait. If you're especially proud of your photobook (and they invariably do look amazing) you can order additional copies – often at a substantial discount – as impressive gifts for friends and family.

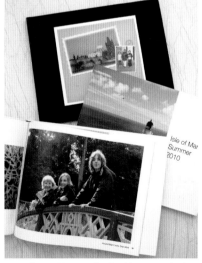

A great keepsake: looking every inch a professional production, photobooks make great keepsakes – and terrific gifts

SHARE YOUR BOOK

If you are particularly proud of your photobook, some publishers let you share it. This allows other family members to buy their own copy of that book recording a special event, or other like-minded enthusiasts to buy your photobook depicting the architecture of Rome, the art of Venice, or whatever your passion happens to be. You'll often get a modest payment or credit for each book sold.

CLEVER IDEA 79:
CREATE A DIGITAL SCRAPBOOK

Mention the word 'scrapbook' to many people and it conjures up dubious collections of press cuttings, old photos, magazine scalpings and the like, stuck haphazardly into a large sugar-paper book. Something we might have made at school and, if the book had survived, not looked at since.

In fact, in this digital age scrapbooking has moved on from those humble and basic beginnings. For many it has evolved into something much more creative and meaningful. Scrapbooks today tend to be less about collecting together random ephemera, and more focused on life stories and their authors' experiences.

Today's scrapbooks also need not even be book-based: your creation can now be presented equally well as an online resource or a lavish photo album. Whether it's a life story, a celebration of a coming of age, or a family archive, why not have a go at creating your own?

GETTING STARTED

Before you start creating your scrapbook, you'll need to come up with a subject. Just about anything can qualify. For the most part scrapbooks tend to be focused around friends or family, celebrating perhaps a retirement, a wedding or a coming of age. We've also seen some great examples of scrapbooks celebrating a school centenary and a notable civic anniversary.

SCRAPBOOKS VS PHOTO ALBUMS

How does a scrapbook differ from a photo album? The demarcation line might be a bit hazy but, with a nod to the more traditional form of scrapbook, today's scrapbooks will also contain non-photographic items. Think of those treasured letters or, perhaps, certificates of achievement, or invites to parties and weddings. All of these, along with photos and specially designed pages, form the basis of your scrapbook.

THE DIGITAL APPROACH

Begin by collecting your materials, for example new and old photos. For old, pre-digital photos, you'll probably want to re-photograph them to create a digital copy. The same applies to other content; documents and other flat artwork can also be photographed for inclusion.

Once you've assembled your collection of images and documents you need to determine how you'll build these into your scrapbook. There are three key options for doing this:

• Print and mount them in an off-the-shelf scrapbook – effective, but not a solution for a quality finish
• Use scrapbooking software to create a digital book, to be printed or shared digitally
• Use scrapbooking software to create an online scrapbook

Scrapbooking software allows you to create a very personal scrapbook. Using templates, you can choose the appearance of every page and alter the layout to best present the items you want to place on it. You're also able to design covers and special pages for your scrapbook.

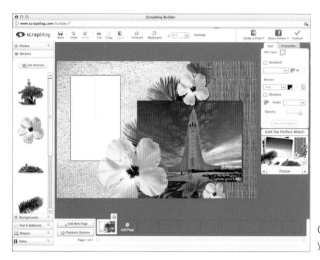

PRODUCING YOUR SCRAPBOOK

The best thing about a fully digital version of a scrapbook is that it can be produced – and distributed – in various different ways. You can produce printed copies, rather like photobooks, directly from the software – as many copies as you like. Or you can publish your scrapbook online through sites such as Scrapblog (www.scrapblog. com) where you can create, edit and then share your scrapbook. The beauty of online scrapbooks is that you can add video and audio resources, too.

Online scrapbooks: using a site like Scrapblog allows you to create, edit and publish your scrapbooks online

SCRAPBOOKING APPLICATIONS

With so many applications available, what should you look for? The following will give you some guidelines:

• Check out the number of templates and album pages provided. Do they have the right look for the type of scrapbook you're considering? Hearts and bows may be ideal for a christening scrapbook, but not so good for other subjects.

• Does the application feature a wide range of text typefaces that you can use to annotate images and artwork, and to add descriptive passages? Again, some typefaces are more suited to specific types of scrapbooks, so it's useful to ensure that you have a wide range available.

• What resources can you import using the application? Photos are a given, but can you import sound and video files if you intend to create a multimedia online scrapbook?

• What can you do apart from create pages? Does the app provide you with the option to produce covers, front pages and so on? And can you produce other projects, such as greeting cards, and wall-mountable prints of pages?

• Can your end product be delivered both online and in print? If in print, is this an easy process?

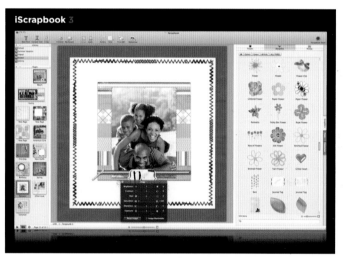

Creation screen: scrapbooking software (such as iScrapbook, shown here) provides you with fantastic control over the way you lay out your pages

Scrapbook covers: software apps also let you create cover artwork

CLEVER IDEA 80:
GO LARGE WITH YOUR PHOTOS

We're all now used to peering at photos on camera or camera phone screens. This is a fantastic way for quickly sharing images, but there is another way to do this – to go large, really large. Below I've listed some ways in which this can be done, along with thoughts on subjects that work well with each finish, and those that might be less successful. But don't take my word for it – experiment.

CANVAS PRINTS

If you want your photographic handiwork to have something of the air of an old master artwork, go for canvas prints. Your image is printed on canvas paper or, for more expensive prints, is transferred to a proper canvas that is then mounted and framed. It's the ideal way of displaying that special photo. Prints produced in this way are generally quite resilient but need an occasional and careful dusting.

• **Works best for:** family portraits, landscapes, traditional scenes
• **Not so good for:** abstracts, contemporary scenes

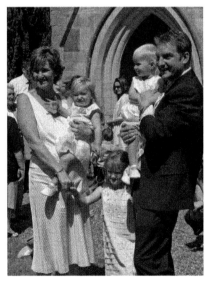

Canvas effect: you can also cheat and apply a canvas effect to your image – and print on plain paper – using image-editing software texture filters

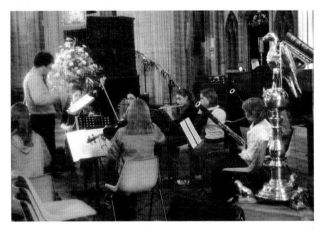

Canvas print: a little ostentatious but perfect for those cherished photos

DIY CANVAS PRINTS

If you print your photos at home, you can create your own canvas prints by buying specialist canvas printing papers. You can print on these in just the same way as you would conventional papers – just check that your printer is compatible with the rather thick paper media. Finish your print off, for maximum durability, with a glass frame and moulding.

BOXED CANVAS PRINTS

Here's a more contemporary twist on the canvas print. Rather than a traditionally styled frame, you get no frame at all. Rather, the print is wrapped across a wooden frame to create something of a 3D effect, with the edges of the print wrapped around the edge of the canvas. If you're looking to produce one of these prints, it makes sense to shoot your photo with a little more space around the subject to allow for the image margins to be wrapped around the frame.

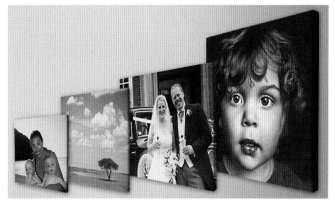
Boxed print: these give a contemporary twist to canvas prints

• **Works best for:** contemporary family portraits
• **Not so good for:** tightly cropped portraits

Acrylic print: these create a glossy, contemporary feel that works best with abstract and bold graphic images

ACRYLIC PHOTOS

This process produces photos that can be backlit or displayed on bright coloured walls. Your photo is transferred to a pane of tough acrylic. Being transparent, you can illuminate your photo from behind using a special lightbox, or mount it just proud of the surface of a wall. Either way you'll get great results, with the colours in the print seeming to leap out at you.

• **Works best for**: bright, simple coloured subjects, abstracts, sunset photos
• **Not so good for:** portraits

ALUMINIUM PHOTOS

Well, you've guessed it, this time your print is transferred to a sheet of aluminium. In some cases a print is merely bonded to a sheet of aluminium (making for a very durable image) but in others the metallic finish shines through.

• **Works best for:** black and white or monochrome, bold graphic photos
• **Not so good for:** portraits, landscapes

 WHAT ABOUT PIXELS?

If you're enlarging a photo to a really large size, won't you be able to see the pixels in the image more clearly? Strictly speaking, yes – the larger the print, the larger the pixel size. But in reality, you'll also be looking at larger prints from a greater distance, so don't worry. Just make sure you do start off with a good, sharp shot.

LARGE PRINTS FROM CAMERA PHONE IMAGES

Some camera phones don't deliver images suitable for really large prints – before committing to them examine your photos closely to see if they will stand the enlargement.

CLEVER IDEA 81:
PRINT PHOTOS ON PHONE CASES

You've used your phone to take photos, so why not use the best of your shots printed on a phone case? You can opt for a single image or perhaps a montage of family shots. You can similarly choose photos to show off on an iPad or Kindle case. Many online photo labs offer these services: Contrado Imaging (www.contradoimaging.co.uk) offers some of the most comprehensive.

Phone case: a great place to enjoy your favourite shot every day. A crafty cut out ensures you can still use the camera unhindered

CLEVER IDEA 82:
PRINT PHOTOS ON RADIATOR COVERS

Some photo printing ideas are a bit off the wall. This one is most definitely on the wall! How about a customized radiator cover? If you are tired of staring at that industrial-style metal or don't like the traditional style of cover, why not go for one of these? They can be made to fit most sizes and – as you would expect – are heat resistant.

Radiator cover: fed up of staring at that white grille? Radiator covers can make the perfect – ahem – canvas for your photos

CLEVER IDEA 83:
PRINT PHOTOS ON ROLLER BLINDS

How about this for your home: a photo on your roller blind. No longer do you have to stare at bland colours or irritating patterns when you pull down your blinds. OK, so you won't see the image all day, but it's a great talking point after dark.

Roller blind: now you see it, now you don't! You'll want to draw down the blinds at any time of the day when they host your favourite photos

THE TROMPE L'OEIL EFFECT

Why not go for the totally wacky trompe l'oeil effect and get your blind printed with an alternative window scene? Replace your actual street or garden view with something more intriguing. Trawl through those holiday photos and by evening you could be looking over Sydney harbour, the pyramids, or the Serengeti!

CLEVER IDEA 84:
CREATE YOUR OWN PHOTO WALLPAPER

For some people a large roller blind image is just not large enough. If that sounds like you, why not go the whole distance and paste your best images over a whole wall? Have your shot reproduced as wallpaper and then hang it as you would conventional paper.

VARIATIONS ON A THEME

If the idea of a whole wall emblazoned with your favourite photo sounds a little extreme, then you could opt instead for something a little less radical. How about a wallpaper border, made up of a repeating mix of some top photos? Or have a bold image printed across a folding room divider? These are great ideas for adding a splash of colour – as well as conversation pieces. Or even dine out on a photo-printed tablecloth.

Photo wallpaper: you can't get much bigger – at home at least – than these whole-wall photos. Just make sure you select photos that you can live with at this size

CLEVER IDEA 85:
CREATE A BANKSY-STYLE ARTWORK

How about having your photos transformed into Banksy-style artworks? Your images can be converted into this popular, contemporary style courtesy of creative photofinishers such as innovative Contrado Imaging in London who produced the example shown here.

A basic image will be reworked to make it appear as if it has been printed on an urban landscape texture – bricks, concrete or corrugated iron – and may even be further embellished with urban furniture such as street signs. The result is very much in the Banksy style. Although most of the work is done for you, the technique still needs a little skill in shooting a photo that will work effectively with the treatment.

Banksy-style print: an innocent, original image can be converted into something that is both compelling and slightly disturbing thanks to this treatment (courtesy Contrado Imaging)

CLEVER IDEA 86:
CREATE A HOCKNEY JOINER

David Hockney is renowned for many things, but particularly his photomontages called 'joiners'. Hockney produced large images that comprised many – sometimes hundreds – of Polaroid images, each of which was taken from a slightly different angle and from a slightly different perspective. Often, shots would also be taken at different times and with different lighting conditions. When reassembled they would recreate the original scene, but in a way that compelled the viewer to look more closely at the detail.

In the style of Hockney: David Hockney's virtual trademark joiner style has been emulated in this holiday scene

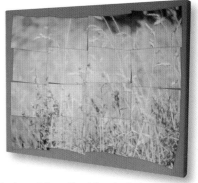

Few of us would have the patience let alone the skill to create our own artwork in the style of Hockney, but you can delegate this process to a photofinisher. Rather than submit lots of separate images, the Hockney effect can be generated from a single one and the results can often transform a good photo into a great one. It's worth mentioning here that these art effects – like any special effects – can work wonders on your best photos, but rarely can they turn a poor or average photo into a great one.

Hockney joiner: The joiner technique can give an interesting perspective on a range of subjects, such as this landscape shot

CLEVER IDEA 87:
GO POP ART WITH YOUR PHOTOS

In a world where the term 'iconic' gets bandied around all too freely, Andy Warhol's image of Marilyn Monroe can justifiably lay claim to such a description. In fact, the image of blocked colours has seen many imitations. So why not create one yourself? This service is available at many photofinishers, but here are a couple of examples created by Contrado.

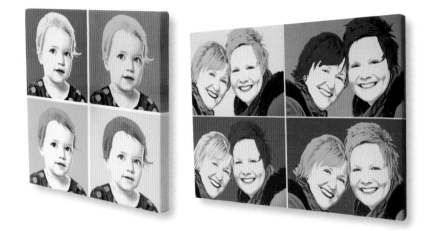

Pop art portraits: The pop art treatment is best suited to portraits and produces a bold, graphic image that deserves to be printed big (courtesy Contrado Imaging)

AND NOT FORGETTING...

Modern printing techniques make it possible to print to just about any surface or media, so the range of products that can feature your images is almost limitless. Here are just a few more of the ways you can enjoy – or share as gifts – your favourite shots:

- Cushions
- Floor cushions
- Beanbags
- Duvet covers
- Blankets
- Triptychs
- Handbags
- Clutch bags
- Wash bags
- Holdalls
- Shopping bags
- Address books
- Journals

- Laundry bags
- Shower curtains
- Aprons
- Storage boxes
- Keepsake boxes
- Snow globes

Anything you want: your best photos can be printed on fabric, leather and plastics, and remain resilient to cleaning

CLEVER IDEA 88:
CREATE ART MASTERPIECES

We've already looked at the way apps on your camera phone can turn your photos into something more artistic. Why not go the whole way and turn your photos into works of art in the style of Monet, Seurat or Edward Hopper? Or turn your favourite portrait into a pastel drawing? All this is possible in just a couple of clicks.

Most image-editing software applications feature filters. Filters, as photographers will tell you, are coloured or textured glass or plastic placed over the lens of a camera to modify the image you're shooting. In digital photography, filters are also software special effects that can transform a digital image in more complex ways than an optical filter ever could.

The most popular of these transformation filters are the Artistic filters that are designed to apply art-like effects to images. They range from brushstrokes through to watercolour effects and canvas-like textures; you can even convert a photo into a line drawing or a sketch. Let's take a look at some of the most popular filters and what they can bring to your photos:

CROSSHATCH

Creates the effect of drawing a dry brush diagonally over the image. It softens the details in the image but leaves well-defined brushstrokes.

• **Good for:** landscapes, still life

• **Not so good for:** portraits

DRY BRUSH

Reduces detail – especially fine detail – as if painted with a reasonably broad brush. Colours become more blocked and with high settings you can achieve a slight impressionist feel to your art.

• **Good for:** landscapes, townscapes, impressionist-style portraits

• **Not so good for:** photos where fine details are important

PALETTE KNIFE

Produces a watercolour effect or, as the name suggests, an appearance of being painted with a fine palette knife rather than a brush.

• **Good for:** landscapes, informal views, character portraits

• **Not so good for:** detailed group shots

POINTILLISE

The photo is replaced with random spots (whose size can be varied) taking the colour from the original image. The background can be black or white or any other colour although black tends to be the most effective.

• **Good for:** stylized images

• **Not so good for:** accurate rendition

TIPS FOR USING FILTERS:

• Always match your filter effect to the image. Soft, delicate effects for feminine portraits; watercolour effects for landscapes. But don't be afraid to experiment!
• Have a go at varying the controls of each filter. Go easy on the settings for smaller images or you could lose important details in the shot.
• If you plan to print on conventional paper you can often enhance effects further by choosing a canvas texture, to give the appearance that the image has been printed on to canvas.
• Keep to one effect! Other than adding a texture such as canvas (mentioned above), don't combine two or more painterly effects – the result is often an indistinct mess.

REPLICATING EFFECTS WITH CAMERA APPS

You can replicate some of these effects with camera apps. Look out for apps such as Mobile Monet that apply painterly effects to your camera phone photos. Apps like these also allow you to control effects by brushing over them with a finger.

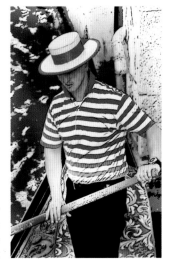

Camera phone art: turn your camera phone photos into artworks using applications like MobileMonet

CLEVER IDEA 89:
SELL THEM

Many photographers – not necessarily professionals – receive a healthy income from their photography. It may not pay enough for an early retirement, but that second income can help purchase a new lens, an additional camera or even your next holiday. Making money from your photos is surprisingly easy. Some methods require a degree of skill, but many are open to the more casual snapper. Here are a few of the ways that people like us are making money every day:

SELL PHOTOS THROUGH PHOTO LIBRARIES

If you upload photos to sites like Flickr, you're well on your way to selling your best photos as Flickr itself allows you to sell photos through the well-respected Getty photo library. If you want to lodge images directly with a library, take a look at iStockphoto (www.istockphoto.com) and Fotolibra (www.fotolibra.com). Both have strong portfolios of work for sale from non-professional photographers.

SELL PHOTOS DIRECTLY

If you have a website it's possible to sell images and prints directly. This is not a quick route to vast riches, but a good way to sell, particularly if you have a photo speciality. Photos of, say, specialized sports or hobbies tend to be less well covered by the major image libraries and so your chance of getting sales – and interest in your site – is greater. I've known some people successfully sell photos on auction sites, too.

CLEAR OUT YOUR OLD KIT

Don't forget you can also make money by clearing out superfluous photo kit. That old or superseded camera, or the accessories you bought, that you thought were a good idea at the time…

Image libraries: many image libraries welcome new contributors, but make sure you only submit your best photos that have a chance of selling

ENTER PHOTO COMPETITIONS

This is not quite such an off-the-wall suggestion as it might sound. Photo magazines, photo websites and the general press are always running photo competitions, often with prizes of photographic equipment. And, perhaps surprisingly, many of these have very few entrants, or few entrants with quality images. You'll probably have to certify that you're not a professional; that is, you do not make a significant part of your income from photography.

SHOOT EVENTS

Events – whether social, sporting or entertainment – provide excellent opportunities for selling your work. If the event is not one that you're closely involved in, it's good form to ask the organizer if they mind you shooting it. This courtesy may be rewarded by you being granted additional access, or being able to shoot from more locations. Don't be offended if you are refused – there may already be a photographer engaged or (particularly with stage shows) copyright restrictions in play. Sometimes, though, persistence can pay off.

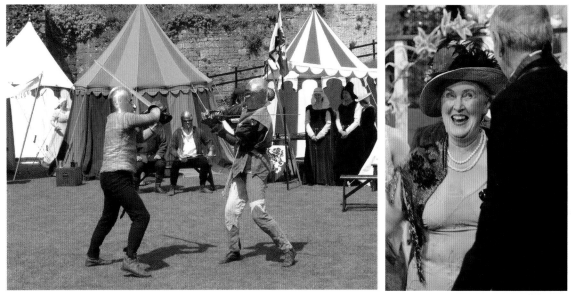

Events: many amateur events – such as this battle recreation and amateur dramatic production – don't have photographers to record the action. Offer to cover the event for free and sell photos to interested parties afterwards

CREATE PRINTS AND FRAMED ARTWORK

Images featuring bold graphics, topical subjects or subjects of local interest can be top sellers, particularly when framed and well presented. Take a look at stalls in craft markets and the like: you'll see the sort of images that sell, and for how much.

Selling framed prints: not as difficult as you might think, particularly if you have photos appropriate to visitors – such as local scenes

HOLD A LOCAL EXHIBITION

If you're feeling bold or ambitious you could even hold a small exhibition, perhaps at a local library or other public space. Even some cafés and restaurants welcome 'free' artworks in exchange, perhaps, for a small commission on sales.

DON'T FORGET THE TAXMAN

It's a sad fact of life that if you make a second income from your photography you'll probably need to declare it to the taxman. And there's no clever idea for getting around this one. Declaration doesn't mean you'll necessarily lose a tranche of your earnings (depending on your status, you may not be eligible to pay tax on it, or you can offset other expenses) but doing so is generally a legal requirement.

CHAPTER 5:
MORE ABOUT YOUR CAMERA OR CAMERA PHONE

Let's be honest. Whether it's a camera, a computer or even a new cooker, we rarely use all the features available on modern devices. We tend to get to grips with what we need and no more. When it comes to cameras that can be something of a shame, so here we'll explore some of the less obvious, but nevertheless useful, things your camera or camera phone can do.

If you get to know – and love – some of the buttons and controls that you normally avoid, they can open up some great new photo opportunities for you, literally at the press of a button. Here we'll explore some of these controls. It's a shame, too, that photography and photographers can get wrapped up in jargon. Pixels? Megapixels? We all think we know what these terms mean, but do we

really know their importance? Let's find out here. In this chapter we'll also look at how you can get the best from your camera phone. Making sure it's all set so that when you press the button you get the best shot possible. In addition, we'll give you some clever ideas to avoid that crushing moment when you realize your battery is flat. Photographically that may be annoying, but when your camera is also your phone a flat battery could compromise your safety, too.

Inevitably the time will come when your camera comes to the end of the road. Whether spurned for a newer model or simply left languishing in a cupboard we'll look at some ways of making even your old camera or camera phone live on!

CLEVER IDEA 90:
DISCOVER WHAT MEGAPIXELS REALLY MEAN

Take a look at the specification of any digital camera. The number of megapixels is generally the lead spec. The traditional understanding has been the more megapixels, the better the camera. This makes sense, right? Not necessarily.

There's no doubt that with more pixels you'll be able to produce larger, more detailed photos. But will this be of benefit to you? If you print your photos no larger than A4 size, or even up to 25 x 20cm (10 x 8in), 5 megapixels will deliver all you need to produce good results.

Cramming more and more pixels on to a sensor doesn't always lead to a better image. The resolution will improve, true, but not the picture quality. If that sounds like something of a paradox, let me explain. To fit lots of pixels – which are small electronic assemblies – on to the small sensor in a compact camera, the pixels have to be small, very small indeed.

As you continually shrink the size of the pixels, you reach a point where they are so small that you get electronic noise and interference between them. This noise becomes random colour changes in our photos – particularly evident when you look at areas of consistent colour, such as blue skies and dark shadows. They just don't look clean.

Image sensor: this is what the image sensor in your camera looks like. In a compact camera it may only measure a centimeter across, yet there may be ten million pixels crammed on to its surface

After being blinded by the constant call for more and more pixels, even camera manufacturers have realized this folly. Now you'll see that compact cameras tend to max out at around the 10 to 12 megapixel level with only those cameras with much larger sensors successfully exceeding this number.

CLEVER IDEA 91:
LOVE YOUR ZOOM

Pro photographers don't like zoom lenses; they view them as mechanically complex with too many compromises. Pros would rather a bag packed with fixed lenses they can swap at will. And why not? They have the time, the budget, and the muscles, to do so. So where does that leave the rest of us with our zoom lens or lenses?

If you want to shoot great, no-nonsense photos, embrace the zoom lens. To be honest, the shortcomings that the pro will use as an excuse not to use them have little effect on our photography. And the benefit a good zoom brings outweighs any shortcomings.

A zoom lens is, first and foremost, versatile. You can be shooting a wide street scene then, moments later, zooming in on a tiny detail. Or you can precisely frame timid wildlife that, were you not able to zoom in, would quickly take flight as you approached to shoot its image.

However don't use a zoom lens as an excuse for laziness. If you can physically get closer to a subject do so. Moving around it can deliver some lovely shots, so don't stand in one spot and expect the zoom to do the hard work!

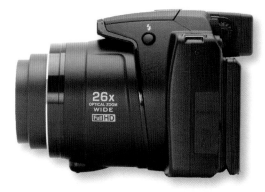

Zooms: zoom lenses with magnifications of 10x, 20x and more, are now available, ideal for homing in on small details in a shot

WHAT'S A DIGITAL ZOOM?

Wily camera manufacturers are able to make a zoom sound far more potent by using the term 'digital zoom' in their specs. You might find written something like 'Maximum 15x zoom', only to read in the small print that this is a 3x optical zoom and 5x digital zoom.

So what's the difference between a digital zoom and an optical zoom? Optical zooms are real zooms: as you change the zoom ratio the individual lenses of the zoom lens move to magnify the image so that a similarly magnified image is recorded on the image sensor. Digital zooms are quite different. This time, the zoom magnification is achieved by recording only the central part of the image on the image sensor and then enlarging it. The overall result is a lower-resolution image.

If you want to get close, shoot at maximum optical zoom. Some cameras let you disable the digital zoom; on others, the zoom control will use the optical zoom first before pausing and switching to digital zoom. If you need to expand further, enlarge the centre of your image when you print or display; the result will be exactly the same or, possibly, slightly better.

TIP

Remember that using a zoom also magnifies camera shake. Ensure you hold your camera firmly when using zooms, or use a stable support.

Digital zoom: there's no doubt that a digital zoom can get you in close, but the quality rarely justifies the use

LEARN WHAT THE BUTTONS DO

Some compact and digital SLR cameras are simple. They have an on/off button, a shutter release button and often little else. Others seem to be emblazoned with buttons, dials, wheels and more, often marked only with cryptic symbols and initials. On this page we'll identify those key controls.

Of course, your camera may have more or less than those shown here, and depending on the model you may find them in different positions. What will be the same is the way that they work. And we'll also look a little more closely at precisely what those controls can do.

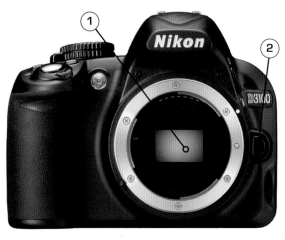

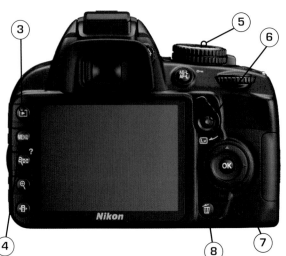

DIGITAL SLR

1. Image sensor
2. Lens release button
3. Image playback
4. Menu
5. Auto exposure lock
6. Live view
7. Menu navigation
8. Image delete
9. Lens zoom ring
10. On/Off
11. Shutter release
12. Exposure compensation
13. Scene modes
14. Exposure mode dial
15. Hot shoe for flashgun
16. In-built flash

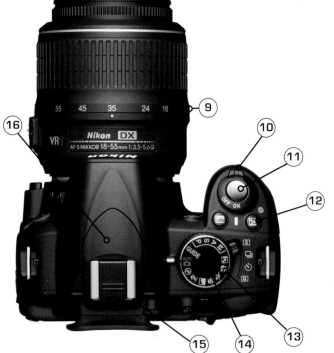

COMPACT

1. Flashgun
2. Zoom lens
3. Zoom control
4. Image view
5. Mode selector
6. Image playback
7. Flash/macro/exposure compensation
8. Menu
9. Delete image
10. LCD display
11. On/Off
12. Shutter release

We've talked about many of these controls as we've looked at clever ideas throughout the book, but here's a helpful recap:

Exposure mode dial: Rotate this to select the exposure mode; for example auto, program, aperture priority and shutter priority. On cameras without this dial you can select your mode from the menus.

Scene modes: These are additional exposure modes designed to configure the camera for particular subjects; for example portraits, action photography and landscapes.

Macro: To take those really close shots of, say, flowers or insects.

TIP

When using the macro facility, take care that the lens doesn't create shadows on your subject.

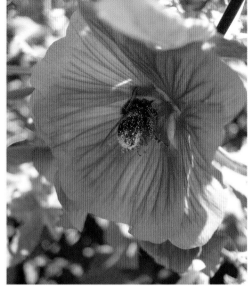

Macro mode: perfect for getting in really close

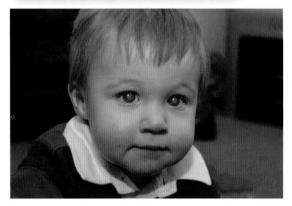

Red-eye reduction flash mode: helps reduce this effect

Flash: This button lets you choose the flash mode. Normally on compact cameras the flash will operate automatically, firing when needed as the light levels drop. There may be additional modes that let you turn the flash off, on and a setting for reducing red-eye.

Exposure compensation: Allows you to vary the automatic exposure the camera has selected. This is useful if the subject is bright or dark, and you want to compensate. It is measured in 'stops': a change of one stop doubles or halves the amount of light that reaches the sensor.

Exposure compensation: varies the amount of light that reaches the sensor

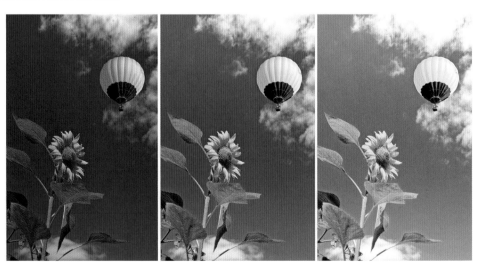

Zoom rocker: press to the left for wide angle and to the right for telephoto. In playback mode you can also zoom in on the selected image by pressing the telephoto end

Shutter release: Press fully to take your photo. There's also an intermediate setting on most cameras. When half pressed, the camera focuses, ready to take the photo. You can use this rather like the autofocus lock – it locks the focus of the shot if you want to move your subject off-centre.

Image playback: Press to review the images that you've already shot. Other controls (usually marked with icons in blue or green) help you navigate the images you've taken – letting you move backwards and forwards through the library, or letting you zoom in on selected shots.

Image delete: Permanently deletes your images.

Live view: Available on some digital SLRs and interchangeable lens cameras, this control allows you to see on the LCD panel (rather than in the viewfinder) the image being received by the sensor.

On/off: Turns the camera on or off. Most cameras power down automatically after a selected time to save battery power.

Self timer: For taking self portraits, this control sets the camera off after a predetermined number of seconds. It also comes in useful for night shots as it reduces camera shake compared with pressing the shutter release manually.

Auto exposure lock/Autofocus lock: Press these controls to lock the exposure settings of the camera, useful if you are recomposing the scene. Autofocus lock is also useful if the main subject of the photo is off-centre. Focus on the subject first, press the lock button and then recompose.

Zoom rocker: On compact and some other cameras this controls the zoom setting. It often has a secondary use: when playing back images it can be used for scanning through them or changing the magnification of a particular one.

ICONS

Baffled by all those icons on your camera? Here's a quick summary of them and the features they indicate:

🌷	Macro		Portrait mode
M	Manual	Av	Aperture priority
▲▲	Landscape		Multishot
	Movie mode	P	Program mode
	Sport/action mode	AUTO	Auto mode
«🖐»	Risk of shake	▶	Playback mode
★	Night scene mode	Tv	Shutter priority
📷	Shooting mode		
⚡	Flash		

Cameras use icons rather than words to describe their function and above you'll see the more commonly used ones. Although there is a degree of standardization, some icons may vary according to the camera manufacturer.

CLEVER IDEA 93:
GET THE BEST PHOTOS FROM YOUR CAMERA PHONE

There's a great quote that says: 'The best camera is the one you have with you'. Well, what if that camera is a camera phone? Should you feel disadvantaged? The answer is – not at all. Today's camera phone is pretty adept – and because you're likely to have it with you almost all the time it makes sense to know how to get the best from it. Here are a few ways to get the very best shots from your phone:

USE THE HIGHEST RESOLUTION

Many recent camera phones come with the option to vary the resolution of the camera. High-resolution images are best if you plan to print them large, want to display them on an HDTV, or you just love detail in your photos. Low resolution is fine if you just want to view your photos on-screen or plan to add them to a website. Why not shoot in high resolution all the time, then? You never know what you might want to do with your photos in the future; shooting in high resolution means you have all the options available to you.

TIP

Larger images take up more memory space on your camera. So if you plan to shoot large a lot, you may have to download images to a computer more often.

CAMERA KITS FOR CAMERA PHONES

If you're not happy with the standard lens on your camera phone this need not be a problem. There are plenty of accessory lenses that you can use to turn your phone into something even more potent – but these do come at the expense of pocketability. The setup shown here even features a microphone for video and a mini tripod for stability. But if you've a separate camera, too, you can't be blamed for thinking this might be a bit of overkill.

Camera phone lens: you can extend your camera phone's lens with accessories like this

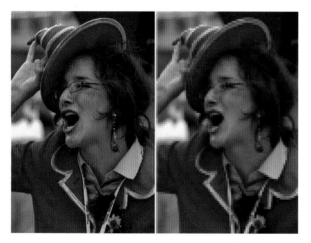

Resolution: low-resolution images may look fine on the camera but when you print them – or view them on a computer – the low resolution becomes obvious

HOLD IT STEADY

Whenever possible, hold your camera phone firmly with two hands when shooting – to limit the amount of shake as you activate the shutter release. For even better results, rest your camera against, or on, a firm support; a wall, a chair, or even against a lamppost. In fact, 'Hold it steady!' should be your mantra when shooting with any camera; use an impromptu support whenever you can, as it will prove time and time again to be a real shot-saver.

GET CLOSE

Most camera phones don't have great zoom lenses. In fact, many don't have real zoom lenses at all. Instead, they have digital zooms that simply blow up the central part of a shot – at correspondingly lower resolutions. This is not ideal for achieving a good image quality.

Avoid any risk of poor image quality by getting close to your subjects whenever you can. Most look better when shot large so do your best to shoot with frame-filling impact. It may not be best for candid shots – real 'in-your-face' photography – but the results will be impressive.

WATCH THE LIGHT

As I've said, the cameras on mobile phones tend to be designed for brightly lit situations. In lower light conditions they probably won't work at their best. Be mindful of this when shooting and make the most of any available lighting. Don't rely on the camera telling you – like a conventional camera does – that the light is poor. The first you'll realize about this is when you see a murky, blurred shot. The flashgun on your camera phone can help substantially – impressive when you see how small it is – but so can moving outdoors for that special group shot, or even drawing back curtains to allow more light into a room.

SHOOT LOTS!

We've said it before, and this can be even more important when using a camera phone; by doing it you'll significantly increase the chances of getting some really well exposed, sharp shots. And because you'll have a camera phone with you at times when you may not be able to carry a separate camera, you could also collect some good candid and impromptu shots.

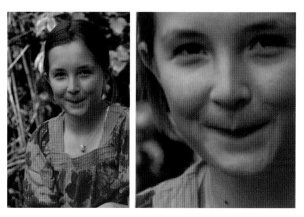

Digital zooms: these may initially seem a clever way to get really close to a subject but they are rarely satisfactory when you look closely at the results compared to a standard shot, as shown here. Always try to physically move in close to your subject instead

YOUR CAMERA PHONE AS A DIGITAL PHOTOLAB

As well as being a camera, many camera phones – especially the ubiquitous iPhones and Android equivalents – are also potent pocket computers. This means that as well as shooting photos you can manipulate them 'live' on your camera phone.

In-camera editing: there are a great many apps that let you edit your photos quickly and easily within the environment of your camera phone

131

CLEVER IDEA 94:
EXTEND YOUR BATTERY LIFE

There's nothing worse when out shooting than to hear your camera emitting a final, pained 'beep' and turning itself off as its batteries use up the last of their power. If you've pulled your camera from its bag, or your phone from your pocket, only to realize you've forgotten to charge the battery, it's a deflating experience and your camera becomes simply a dead weight. Losing power on your camera phone can be even more of a blow, as you lose your communication facility and information bank, too. However, by taking a few simple precautions and adopting some standard good practice, you can make sure you never find yourself in this position:

- Keep your camera in a cool, dry environment whenever you can to help the battery last so the camera is always in best condition to shoot.
- LCD screens use more power than the viewfinder. If your camera has an optical viewfinder, use this to compose shots to extend battery life substantially. Also limit shot reviews on the camera's LCD screen.
- Ease off using the flash as that tiny flashgun on your camera also has a voracious appetite for energy. Don't turn it off altogether, but use it sparingly or only when the available light is too poor for a good shot.
- Always take your charger – and plug adaptors – when travelling. This is another of those obvious measures, but it's surprising how easy it is to forget to bring the right plug converter for the country you're visiting.

For camera phones you can do even more to extend battery life:

- Don't browse the web more than you absolutely need to.
- Turn off Bluetooth when it's not needed, and the same goes for WiFi.
- Turn down the screen brightness.
- Avoid using – or even switching on – instant messaging services and, if power is critical, avoid email services, too.

CARRY A SPARE

This may seem a bit obvious – and expensive, given the cost of some batteries – but a spare battery (or two) is an easy way to guarantee extended shooting, virtually uninterrupted. Simply ensure that you charge – or top up – these at the same time as the main battery. Special note to iPhone users: you can't change the battery, so make sure you have a charger with you!

Phone add-on battery: battery packs like this can be clamped on a phone (in this case an iPhone) to provide greatly enhanced battery life. A cut out ensures the camera lens is not obscured

(I) CHEAP BATTERIES

Spare camera batteries from third party manufacturers are available from many reputable sources. Camera manufacturers treat them with disdain and don't encourage use. However in general there's rarely any problems with them, although they often have lower capacities than the manufacturer's own, often much more expensive, offerings.

Cheap batteries: many camera stores sell look-alike batteries, often at a substantial discount compared with the manufacturers' own

CLEVER IDEA 95:
USE THE SUN FOR POWER

If you don't trust the local power in your location or are likely to forget the overnight charge, try adding a solar charger to your kit bag. These devices are ideal for that remote trek or extended adventure, even in less sunny climes.

Models like the Solio folding charger shown here come with connectors to work with the most popular phones and cameras. Their only downside is that it can take some hours to charge a completely flat battery.

Solar charger: perfect for topping up batteries anywhere

CLEVER IDEA 96:
PROVIDE A LONG, HAPPY LIFE FOR YOUR CAMERA

Most cameras today are remarkably robust and can withstand a fair bit of abuse from both the elements and their owners. A few cameras and a greater number of phones are designed to be kept in a pocket or purse without any additional protection. For all others, a case – even if it is only a slip-in one – is recommended. This will help insulate the device from knocks and the ingress of dust and should prove sufficient to cope with everyday situations.

But what if things get more extreme? Apart from the more obvious risks of theft, physical damage and the like, there are four known enemies of your camera, all of them environmental. Let's take a look at them and some of the ways to protect your device from them – no matter how extreme your photography becomes.

HEAT

One of the most damaging places – in terms of heat – is not the Wadi Rum, nor the deep Sahara. No, heat is more likely to damage your camera when you leave it in a car on a hot day. For protection – and to avoid the obvious risk of theft – take it with you! You can also use a camera bag or case to – at least partially – limit the effect of direct sunlight, but keeping your camera away from extreme heat is a better solution.

If, for whatever reason, your camera does get hot, quickly cover it or remove it from the hot car environment. Wait until it is cool before trying to use it again and check the memory card. Many people recommend changing the card after exposure to high temperatures; this is a good safety move, but one that others would argue as excessive.

In addition, LCD screens can turn black at high temperatures. This condition looks terminal but the screen should return to normal when the temperature drops.

COLD

Your camera and camera phone can successfully survive cold conditions, but with a couple of caveats. First, battery power tends to tail off in colder conditions. Keeping a spare one in a warm pocket can be very useful to resurrect a powerless camera. Second, take care when returning to warmer climes. Keep the camera in a bag or pocket so that it can return to room temperature gradually. Bringing it straight into a warmer temperature risks condensation inside and outside the device.

Snow: most compact cameras can be stored in a waterproof pocket for those great snow shots – just make sure you don't operate with snowy fingers

WATER

Assuming your camera is not designed for use in water, there's one crucial piece of advice to follow if your camera has the misfortune to get a good soaking. *Don't turn it on to see if it still works.* It's a temptation, but to do so could wreak havoc as the mild power spike that normally brings your camera to life will become a killer surge. Instead, remove the battery and memory card. You can still do your best to retrieve any images that may be lingering on the latter.

A good dousing with salt water can be fatal due to the corrosive effect of the salt on the delicate circuitry. Some recommend quickly flushing the camera with pure water to remove the salt, but I'm loath to do so. Such action can push water further in and cause more consequential damage. Your only recourse is to seek urgent professional help. If help is not readily at hand, you could attempt to let your camera dry out and then try powering up. But that really is a last resort situation; in some cases people have been lucky, others not so.

TIP

Determined to take your camera underwater? See the advice in **Shoot In and Around Water**.

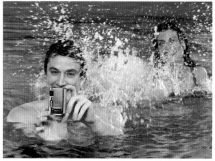

All at sea: whether used by the pool or sea, some cameras are quite safe to take with you. Do, however, ensure that you rinse any salt or chlorine off before packing the camera away, following manufacturers instructions

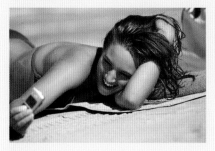

Dust and sand: Spectators to events like these rally stages can find themselves in an artificial sandstorm

Beaches: steer clear of the sand and the water if your camera or camera phone is not sufficiently protected

DUST AND SAND

Dust is everywhere and no matter how fastidious you are about keeping it at bay some will find it's way on to – and into – your camera. Sometimes the problems it causes are transient, and easily solved. Dust on a lens, for example, can be cleaned away using an air blower, approved brush or a microfibre cloth.

Too much dust, though, and you'll have more substantial problems. With interchangeable lenses you might find – no, you will find – dust can creep inside the body of the camera. Dust particles can easily make their way to the image sensor because, very annoyingly, the sensor tends to have an attractive electrostatic charge.

Many cameras today feature sensor cleaning routines – usually an ultrasonic wave that passes across the sensor to dislodge particles – but if soiling is more pronounced, I'd recommend professional cleaning. It's not prohibitively expensive, and it's an option I prefer to DIY kits.

Think of sand as dust particles on steroids. After just a moderate exposure to a sandy environment, tragic things can start happening to your camera. Where dust ingress can be annoying, sand ingress can be terminal. Small grains can cause mechanisms to seize and your camera to report a message that, for all intents and purposes, declares it dead.

CLEVER IDEA 97:
SELL YOUR OLD KIT

Offset the cost of your new camera by selling off your old kit. Unless it's very old or very damaged, you might be surprised at how much value your old camera still holds. Throw in any accessories that you might have for it – which are probably incompatible with your new acquisition – and you could make a tidy amount, lessening the financial impact of your new purchase.

If you do decide to sell, get the best possible price by ensuring the camera is in good, clean condition and that it's complete with all the original accessories – including, where possible, the box and manual. Although you can find copies of manuals online, and boxes don't contribute to the camera itself, including them as part of the sale makes a better impression with buyers. You've clearly looked after your kit; and that translates to a better price.

Where's the best place to sell? Retail stores specializing in pre-owned goods tend to give poor prices but transactions can be simple. Online auction sites offer a better opportunity – but remember to factor in the cost of sales and postage. These sites also tend to have the widest audience so if you're selling something that little bit special, the chances are that you'll find some eager buyers who recognize its worth.

Sell your kit: you may not get the best prices selling through a traditional retailer but it can be a lot less hassle than selling online

> **TIP**
>
> When selling through traditional outlets, you'll do better if you trade in your kit for a new model.

CLEVER IDEA 98:
PASS ON YOUR OLD CAMERA

Although camera prices are falling, they are still unaffordable to many. If you're not inclined to sell your camera – or just don't think it has enough monetary value – consider donating it to a person or an organisation that will treasure it. There are plenty of organisations that run photo clubs for younger people; these would be delighted to accept your donation. Or if you know someone yourself who could make use of it – to start themselves on a lifetime's passion for photography – why not pass it on to them?

CLEVER IDEA 99:
USE YOUR OLD CAMERA FOR STUNTS

Some photo opportunities are plain crazy. Not necessarily dangerous (no opportunity should put you in danger), but something that could harm your camera. If you've just invested in a new camera the last thing you want to do is to push it to the limits of physical endurance. Instead, why not call your old camera back for the task? Head off for those risky adventures armed with your old camera, and armed with the certainty that if it gets damaged, lost or even destroyed, it's just annoying rather than disastrous. And in any case, you might have got some great shots along the way!

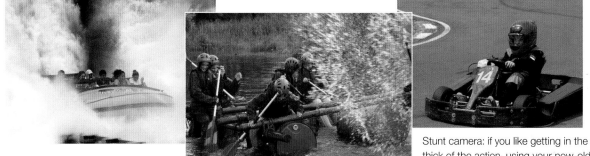

Stunt camera: if you like getting in the thick of the action, using your now-old camera can save your latest investment from harm

CLEVER IDEA 100:
EXPERIMENT WITH YOUR OLD CAMERA

Here are a handful of suggestions for what you might do with your old timer:

- **Use it as a webcam:** Old cameras have smaller pixel counts and could be ideal for this, and you can lock them into webcam mode. In retirement you could actually end up using your camera more.
- **Replace the lens:** Play around by replacing or augmenting different lenses. Try looking glasses, magnifiers or pieces of Fresnel glass.
- **Set up an easel mount:** Mount your old camera on a semi-permanent easel so you can quickly and easily photograph flat artwork and documents.
- **Experiment with pinholes:** Pinhole cameras were perhaps the earliest of cameras and create intriguing results. Replace your lens with a perforated opaque card and watch the results.

Pinhole camera: replacing your lens with a simple pinhole can produce interesting effects like this

CLEVER JARGON BUSTER

I did my best in this book to keep jargon to a minimum, but as photography is littered with it, sometimes its use was unavoidable. Here I've gathered together all the terms I've had to use – plus a few more that may come in useful.

Accessory shoe: Standardized mounting found on top of many cameras for the attachment of external flashguns and other accessories

Angle of view: The angle of a scene covered by a specific lens, measured across the diagonal of the frame

Aperture: The opening in a lens that allows the light to pass through. This is controlled by an iris – rather like that in an eye – under manual or camera control, and is varied along with the shutter speed to achieve correct exposure

Aperture priority mode: An exposure mode where the photographer selects the aperture and the camera sets a corresponding shutter speed

Autofocus: Focusing system that automatically focuses on the subject or point determined by the photographer

Automatic exposure: A camera setting, used in digital and film cameras, where the camera assesses and sets the aperture and shutter speed

Automatic flash: Electronic flash that is activated automatically when light levels fall. Normally this can be overridden to prevent the flash operating when not required

Back-lit, Back lighting: A light source that illuminates the subject from behind and usually requires exposure compensation (or fill-in flash) to achieve accurate exposure of the subject. Some serious photographers call it 'contrajour'

Balanced flash, Balanced fill-in flash: A flash system that balances the amount of flash light with ambient light to brighten any shadow areas

Bridge camera: See **Hybrid camera**

Camera phone: Mobile phone with integral digital camera

Card reader: Device that allows memory cards to be read by a computer. Most memory card readers will accept more than one format of card

Centre weighted metering: The default type of metering in most cameras. This takes readings biased towards the centre part of the frame on the basis that this is where the subject is most likely to be placed

Charge-coupled device (CCD) image sensor: The imaging sensor used in the majority of digital cameras

CMOS image sensor (CMOS): An alternate image sensor to the CCD that uses different technology and is favoured for it's lower power consumption

CompactFlash: Type of memory card now mainly restricted to professional cameras

Compression: A way of storing an image file more compactly so more image files can be stored on a memory card. It also makes the online transfer of files faster

Depth of field: The distance between the nearest and farthest points that appear in acceptably sharp focus in a photograph. Depth of field varies with lens aperture, focal length, and camera-to-subject distance

Downloading: The process of transferring images, and any other data, from a camera to a computer

DSLR: Digital SLR – see **Single lens reflex**

Electronic viewfinder (EVF): A viewfinder used in some digital cameras that uses a small LCD panel behind a conventional viewfinder eyepiece

Exposure: The amount of light falling on the image sensor of a camera when taking a photograph. It is varied by adjusting the aperture and the length of time the shutter is open

Exposure compensation: The adjustment of a metered exposure to allow more or less light through to the sensor in order to compensate (usually) the brightness or reflectivity of the subject

Exposure/focus lock: A feature found on some cameras that allows the exposure settings or the focus to be locked by pressing either the shutter release partially, or depressing a separate button

Filter: A piece of optically transparent material placed over the lens of a camera to modify the incoming light by colouring, diffusing or restricting the light entering the lens. Also a term used to describe digital effects that modify images in a similar way – or often, in more extreme ways

Firewire: A fast data transfer system used for digital images and (especially) digital video. Largely superseded now by USB 2 and 3, and Thunderbolt

Flash, fill-in: A burst of electronic flash used in bright lighting conditions to prevent dark shadows in subjects. Needs to be accurately balanced with the ambient lighting for best effect

Focal length: The distance between the centre of the outermost lens element of a camera lens to the imaging sensor when the camera is focused at infinity. Normally expressed in millimeters, the focal length also determines the angle of view of the lens and the amount of a scene that can be included in one shot

Focus lock: see **Exposure/focus lock**

Focus: The point where the light rays from a subject are brought together to form an image

Four thirds: A standardized camera image chip used particularly by Olympus and Panasonic. Micro four thirds is a variation on this format that uses the same size sensor but allows for smaller, compact camera designs, such as mirrorless SLRs

F-stop, f-number: A setting of the lens aperture. Normally consecutive f-stops are factors of 2 of the aperture opening (for example, f4 is half the aperture of f2.8). F-number is often used to describe the maximum aperture of a lens

Hot shoe: see **Accessory shoe**

Hybrid camera: An informal name used to describe cameras that are ostensibly compact designs but have some features and specifications found on SLR cameras (see also **Interchangeable lens camera**)

Image manipulation application: Software designed to manipulate and edit digital images. Photoshop is the most renowned of these

Image sensor: Think of this as digital film – the part of a camera that records the image. Can be a **CMOS image sensor** or **Charge-coupled device** (see above)

Inkjet printer: Computer printer that uses a technique where minute quantities of ink are 'sprayed' on to paper. Most inkjet printers are capable, with the appropriate papers, of producing photo quality prints

Interchangeable lens camera: A camera that features interchangeable lenses. Usually applied to four-thirds format cameras (such as those from Panasonic and Olympus) that are similar to dSLRs but don't have the direct viewfinders

iPhoto: Photo downloading, cataloguing, storage and manipulation application found on all Macintosh computers

ISO: In photography, used to denote the sensitivity of film and the equivalent sensitivity of an image sensor. Higher numbers indicate proportionately higher sensitivity

JPEG: Short for Joint Photographic Experts Group. More commonly the name of a file format used to store images on memory cards and computers, popular because it allows small file sizes

Landscape mode: An image recorded in horizontal format (compare with **Portrait mode**)

LCD monitor screen: The screen found at the back of digital cameras used to preview images and review photos recorded by the camera

Macro: Term used to describe reproduction where the image size is the same, or larger, than the original object. Tends to be more loosely used in digital cameras for extreme close ups

Macro mode: A switchable lens mode designed to allow photography of small objects at a large scale (see **Macro**)

Matrix metering: A camera metering system that evaluates the exposure at a large number of points across the scene before evaluating an overall exposure

Megapixel: One million pixels, used to describe image sensors (5 megapixels = 5 million pixels)

Memory stick: A memory card system used in Sony cameras

Multiple exposure: A single image comprising two or more image exposures that are superimposed in-camera

Noise: In digital photography, interference produced by random fluctuations in an electronic circuit. Most obvious in digital images recorded using high ISO settings

Optical viewfinder: Camera viewfinder that relays an actual image (rather than an electronic image) to the eyepiece

Orientation sensor: A sensor found in some cameras that determines whether a photo has been shot in portrait or landscape format, and then displays images accordingly

Overexposure: Allowing too much light to reach a sensor, compared with the assessed exposure. May be done accidentally or intentionally for creative purposes

Panorama: A photograph that has an aspect ratio wider than that of a conventional image sensor and a particularly wide (up to 360 degrees) angle of view

Panoramic mode: A digital camera mode that allows multiple shots to be co-joined to produce a wide (or a tall) panoramic shot

Photoshop: The leading application used by virtually all professionals and enthusiasts – and priced accordingly. A trimmed version, Photoshop Elements, provides much the same functionality at a lower price

Pixelation: The results of enlarging a digital image, or part of a digital image, too much so that individual pixels become visible

Pixels: Contraction of Picture Element: the individual elements that comprise an image sensor and, consequently, a digital image

Portrait mode: A photograph (not necessarily a portrait) shot with the longest dimension upright (compare with **Landscape** mode)

Preview screen: Alternate name for LCD monitor panel

Programme/program exposure: An automatic exposure system where aperture and shutter speed are set according to a program optimized for the majority of shooting situations

RAW format: An image format produced by digital cameras that does not impose any compression or post processing, allowing the photographer to extract the maximum quality and information

Red-eye, Red-eye reduction mode: A flash mode that fires single or multiple pre-flashes to close the iris of subject's eyes prior to the main flash. Sometimes useful in preventing the retinal reflections that appear as bright red

Resolution: The amount of detail that can be resolved in a digital image and is substantially based on the number of pixels that comprise the image. Higher resolution images contain more detail and can be enlarged further when printing without the pixel nature becoming visible

Scene modes: Pre-configured camera settings that, when selected, set camera controls to their optimum settings for specific subjects. Examples are **Landscape**, **Portrait** and Sports. For each case the focal range, lens aperture and exposure time will be configured to enable the photographer to get the best results automatically

Shutter speed: The length of time the shutter is kept open to allow an image to be formed on the image sensor

Shutter: The mechanical device in the camera that opens to allow light from the scene through to the imaging sensor and effect the exposure

Shutter priority mode: An exposure mode where the photographer selects the shutter speed and the camera automatically sets the aperture. Ideal for action and fast moving subjects

Single lens reflex (SLR): Camera in which the same prime lens is used for producing images and feeding the viewfinder. Most – but not all – SLR cameras also feature interchangeable lenses

Spot metering: Metering mode where an exposure reading is made from a small, discrete area of the scene – normally indicated by a circle at the centre of the viewfinder

Stop down: To decrease the lens aperture

Super wide-angle lens: see **Wide-angle lens**

Telephoto lens: A lens with a long focal length that has a narrower angle of view than a standard lens or the human eye

Through-the-lens: A metering system that measures exposure through the lens used to take photographs (rather than using an external sensor that measures ambient lighting conditions). Also used to describe the viewing system in SLR cameras where the viewfinder displays the scene through the prime lens

Thunderbolt: A relatively new communications/connection system for computers and peripherals. It has been pioneered by (although not invented by) Intel and Apple

TIFF: Short for Tagged Image File Format. An image file format popular in digital cameras that, unlike JPEG, is lossless. A TIFF image does, however, require more storage space

TTL: see **Through-the-lens**

Ultra wide-angle lens: see **Wide-angle lens**

Underexposure: Intentional or accidental decrease in exposure resulting in less light arriving at the sensor than an accurate exposure would suggest

USB: A communications system between a computer and peripherals (including cameras) for the transfer of data. USB 2 and USB 3 are faster versions of the original USB

Viewfinder: A viewing system for seeing the view that will be recorded on your photos

White balance: A camera control that ensures the colours in a scene are accurately reproduced no matter what the lighting conditions. Can be disabled if a photographer wants to introduce deliberate colour casts

Wide-angle lens: A lens with an angle of view wider than a standard lens. Those with a wider angle of view are sometimes called super wide, and those wider still, ultra wide

Zoom lens: A lens that lets you change focal lengths (and image magnification) continuously between wide angle and telephoto (usually)

INDEX

A DAVID & CHARLES BOOK
© F&W Media International, Ltd 2012

David & Charles is an imprint of F&W Media International, Ltd
Brunel House, Forde Close, Newton Abbot, TQ12 4PU, UK

F&W Media International, Ltd is a subsidiary of F+W Media, Inc
10151 Carver Road, Suite #200, Blue Ash, OH 45242, USA

Text and Photography © Peter Cope 2012, except those listed on page 4
Layout © F&W Media International, Ltd 2012

First published in the UK and USA in 2012

Peter Cope has asserted his right to be identified as author of this work in accordance with the Copyright, Designs and Patents
 Act, 1988.

A catalogue record for this book is available from the British Library.

ISBN-13: 978-1-4463-0216-3 paperback
ISBN-10: 1-4463-0216-4 paperback

Printed in China by RR Donnelley for:
F&W Media International, Ltd
Brunel House, Forde Close, Newton Abbot, TQ12 4PU, UK

10 9 8 7 6 5 4 3 2 1

Acquisitions Editor: Neil Baber
Assistant Editor: Hannah Kelly
Project Editor: Freya Dangerfield
Proofreader: Beth Dymond
Senior Designer: Mia Farrant
Production Manager: Beverley Richardson

F+W Media publishes high quality books on a wide range of subjects.
For more great book ideas visit: www.rucraft.co.uk